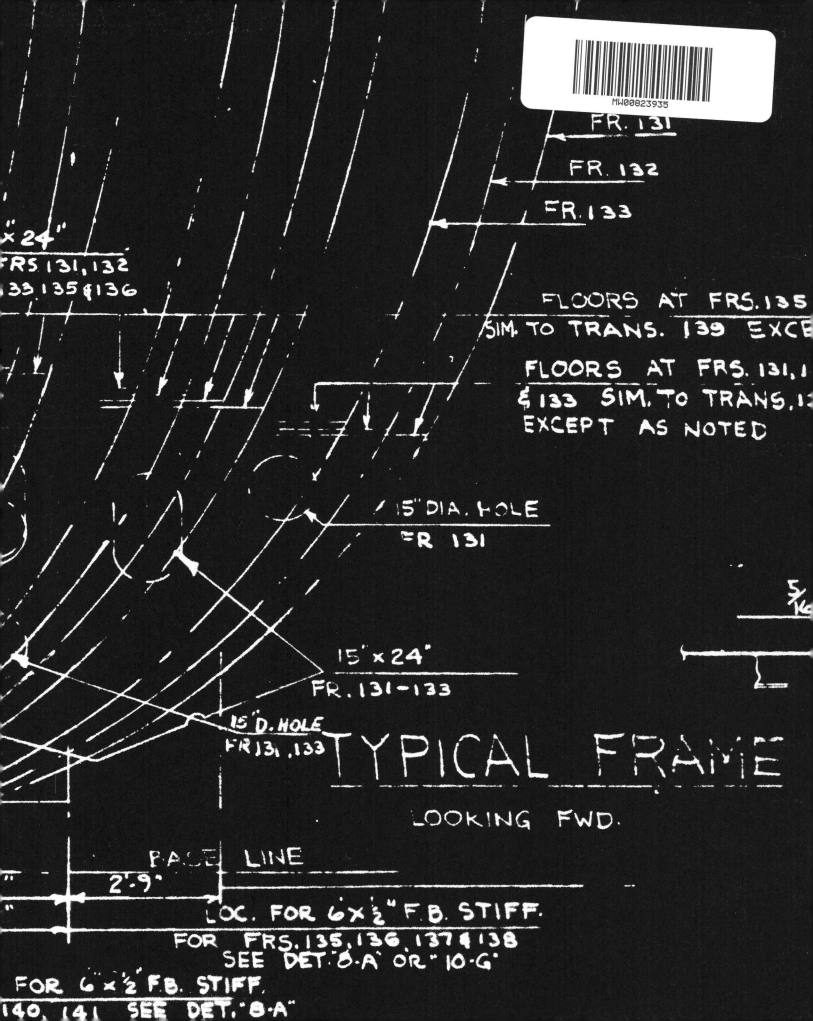

FR. 131

FR. 132

FR. 133

×24"
FRS.131,132
33,135 &136

FLOORS AT FRS.135

SIM. TO TRANS. 139 EXCE

FLOORS AT FRS. 131,1
& 133 SIM. TO TRANS, 12
EXCEPT AS NOTED

15" DIA. HOLE
FR 131

15"× 24"
FR. 131-133

15"D. HOLE
FR 131, 133

TYPICAL FRAME

LOOKING FWD.

BASE LINE

2'-9"

LOC. FOR 6×½" F.B. STIFF.
FOR FRS.135,136,137 &138
SEE DET. "8·A" OR "10·G"

FOR 6 × ½" F.B. STIFF.
140, 141 SEE DET. "8·A"

For my mother,
Marlis Zeller Cambon,
who gave me roots and wings

and for Usha Bora,
my beautiful jaan,
who helps me soar.

Shipbreak

Claudio Cambon

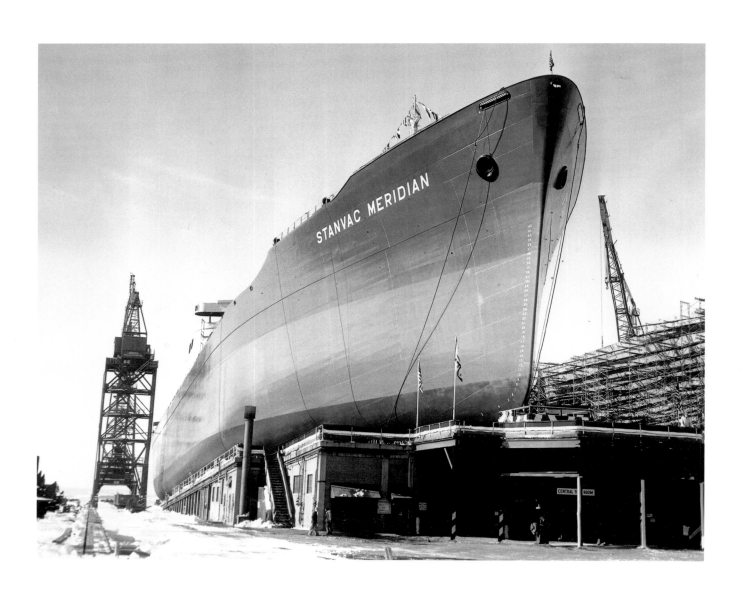

Launch Day, Sparrow's Point Shipyard, Baltimore, Maryland, November 1961.
The *Stanvac Meridian* was soon renamed the *Mobil Meridian*, then the *Seminole*, and finally, the *Minole*.

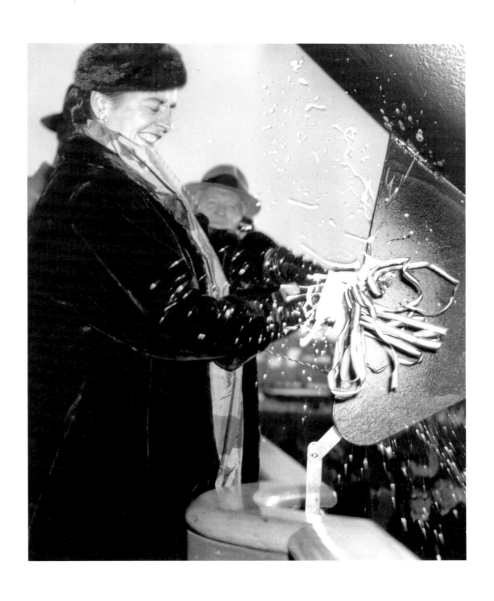

When the American-flag oil tanker *SS Minole* beached in the breaking yards of Chittagong, Bangladesh in January 1998, it signaled both an ending and a beginning. For the American sailors who ran the ship aground, this event meant the close of a long, productive life spent wandering the world's oceans. For the Bangladeshi shipbreakers who over the course of the next five months dismantled the vessel, more or less by hand, it signified instead a point of commencement, because the ship provided many materials necessary to their country's struggle to create a modern existence for itself. The death of one man's livelihood became the birth of another's.

However, more than a ship was exchanged in this process. To all of them she was not just a carrier of cargo, but an emblem of life itself; like all living things she decomposed, and her recycled elements formed the basis of new organisms: a hull became building rebar, a machete, a drum tensioning rod, a religious statue. These photographs give record of this transformation; they ultimately serve as a meditation on how life possesses us more than we do it, and how it mysteriously changes shape from one beautiful form to another, passing through us like light through the filament of a bulb.

Al Wheeler, Chief Engineer (ret.), *Mobil Meridian*, July 1999
Klaus Lohse, Captain (ret.), *Mobil Meridian*, July 1999

Rogers Schwartz, Captain (ret.), *Mobil Meridian*, July 1999

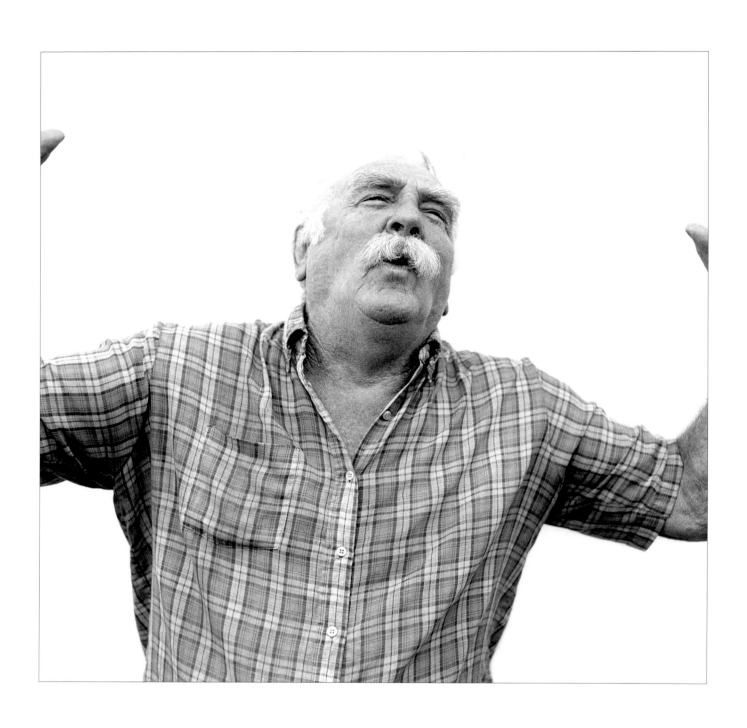

Johnny Petrovich, AB Seaman (ret.), *Mobil Meridian*, July 1999

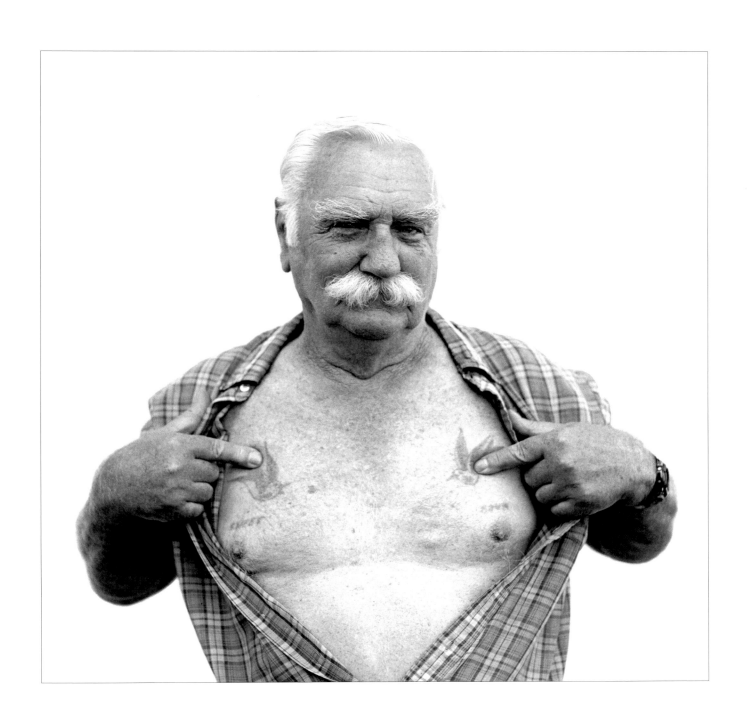

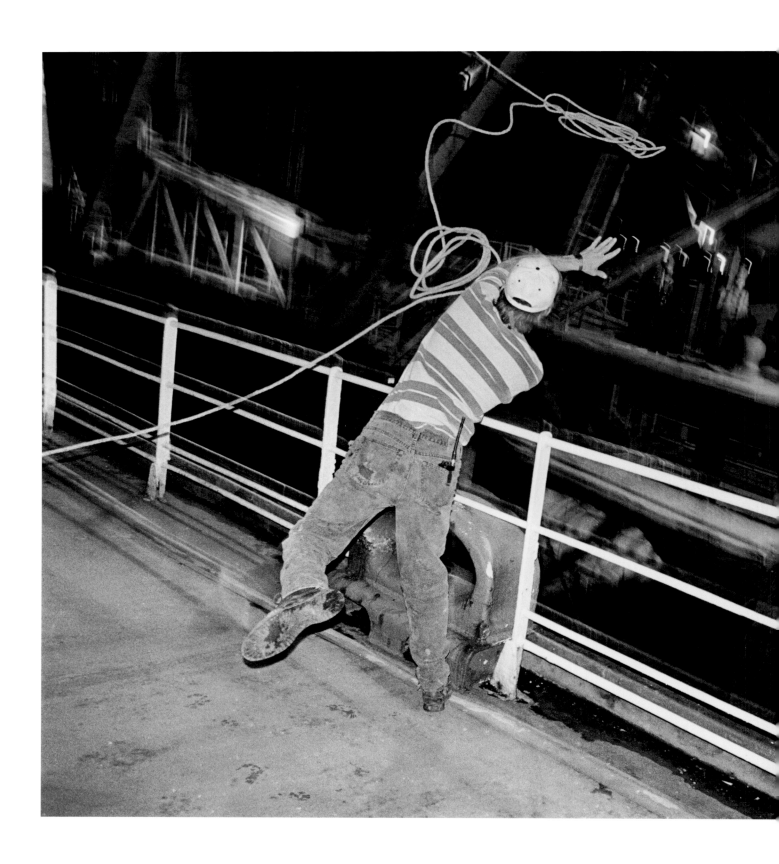

The *SS Minole* ties up to load her final cargo,
Port Allen, Louisiana, November 1997

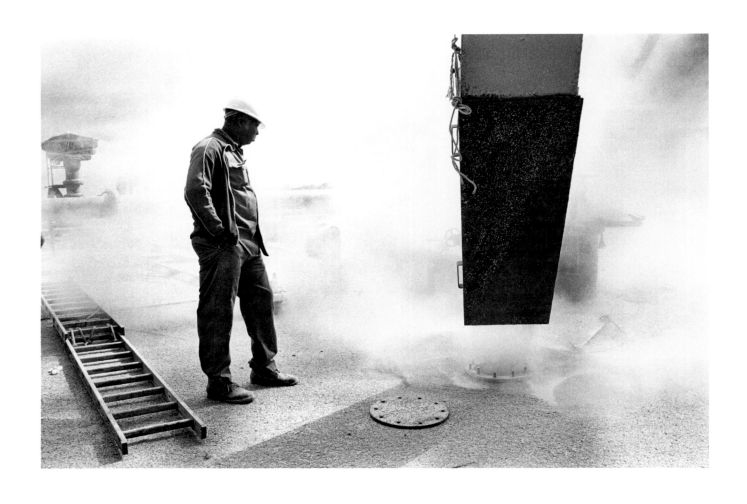

Loading the ship with grain

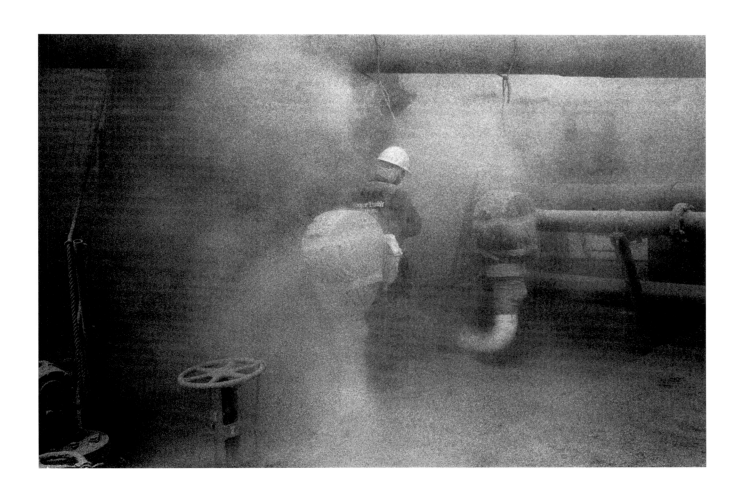

Leaving, Baton Rouge, Louisiana, November 18, 1997

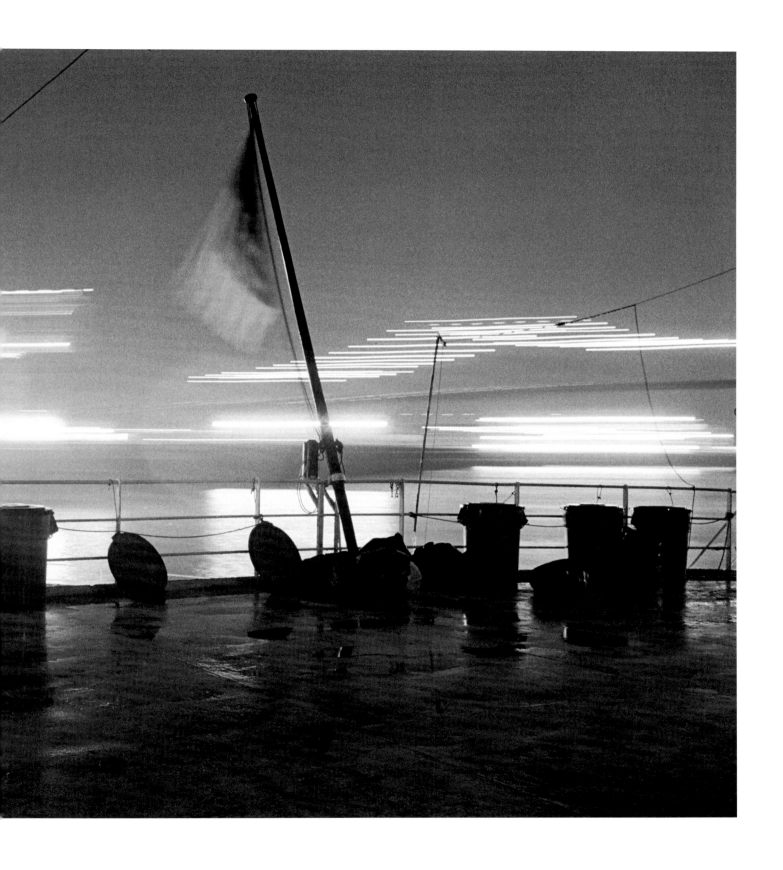

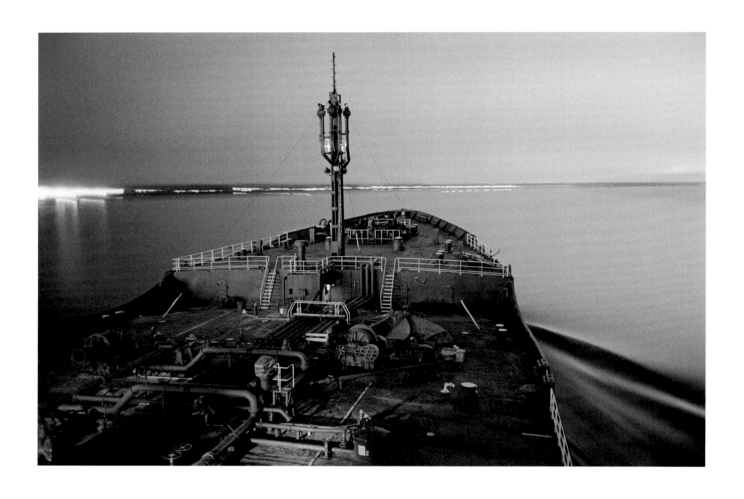

Heading down the Mississippi River

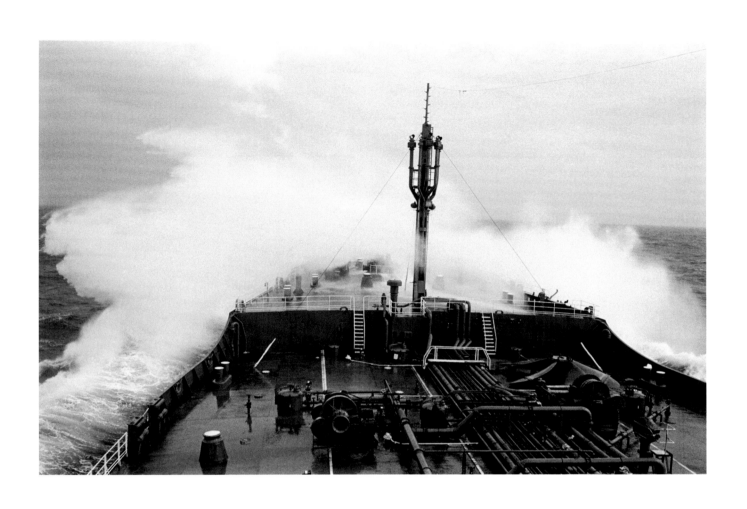

Open ocean, Gulf of Mexico

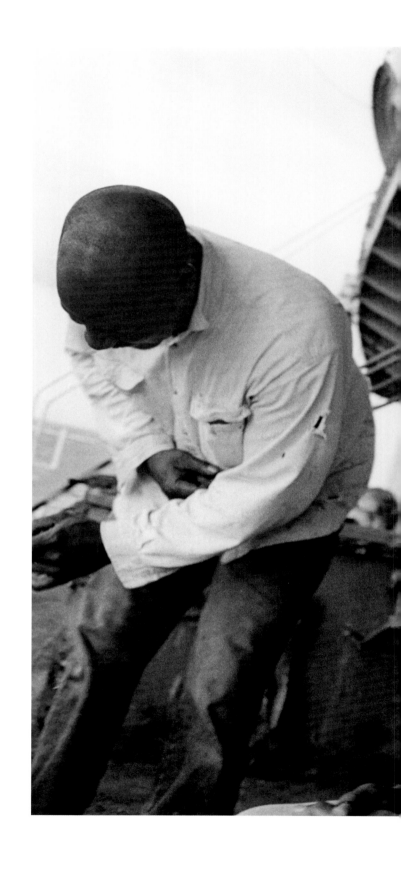

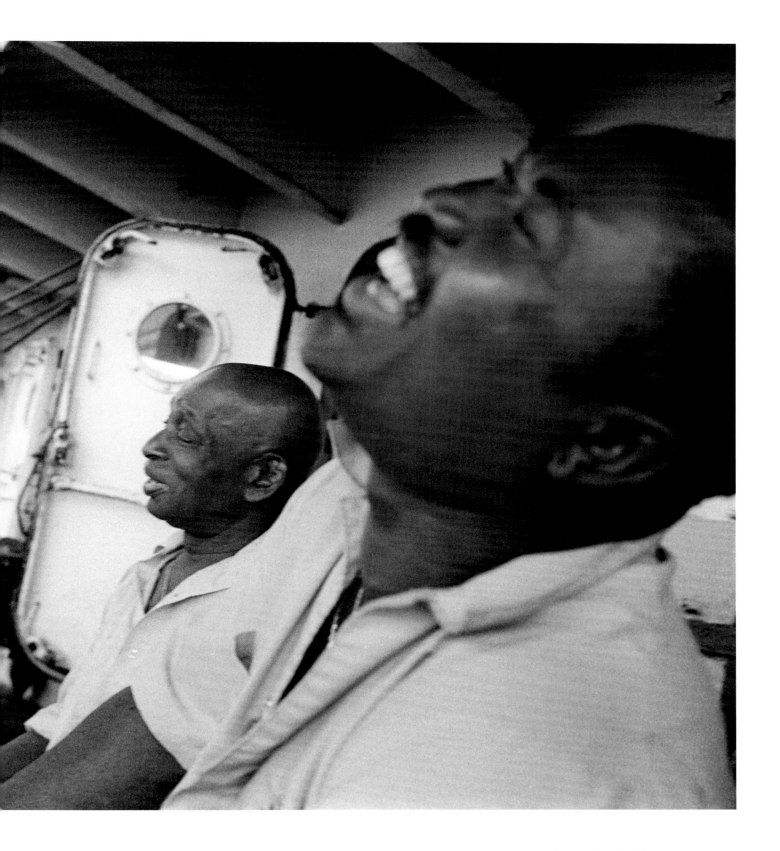

Out on the fantail after dinner

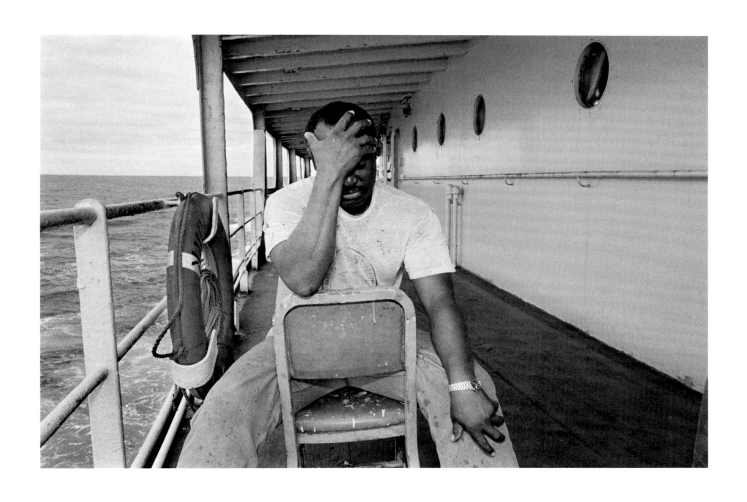

Noah Tanihu, AB Seaman

South Atlantic

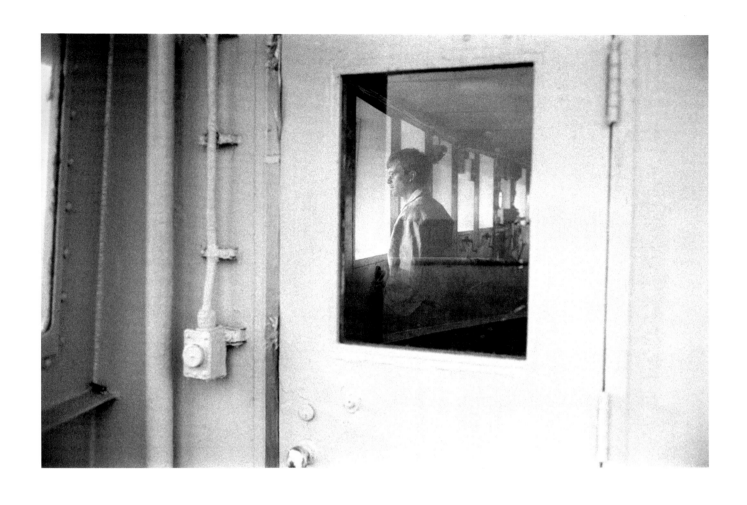

Ron Wood, Chief Mate

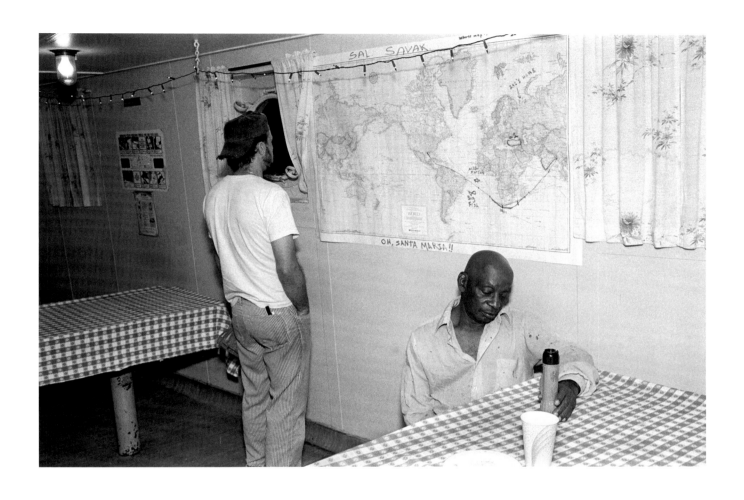

Crew's mess, Christmas Eve 1997

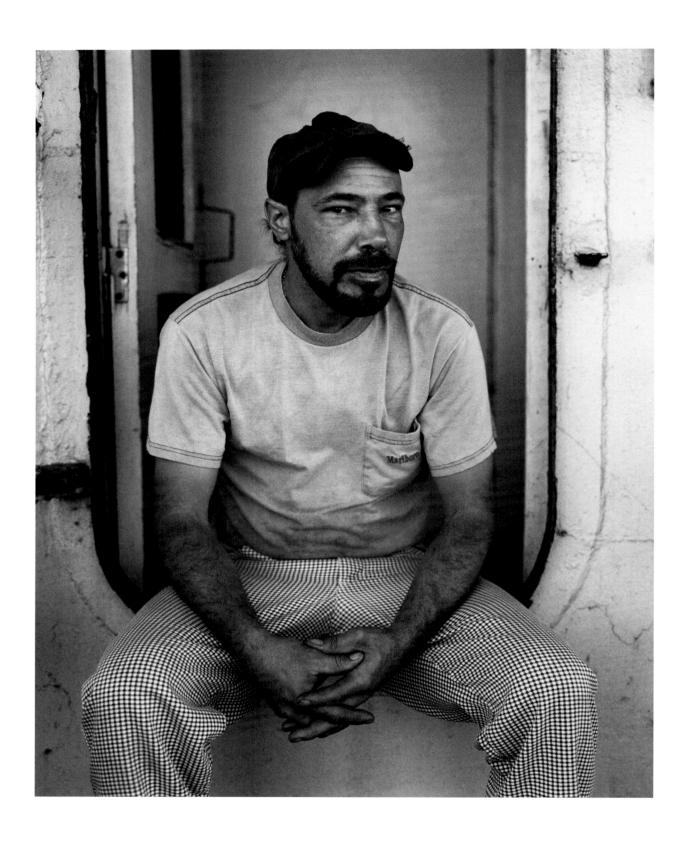

Robert Organ, Chief Cook and Chief Steward

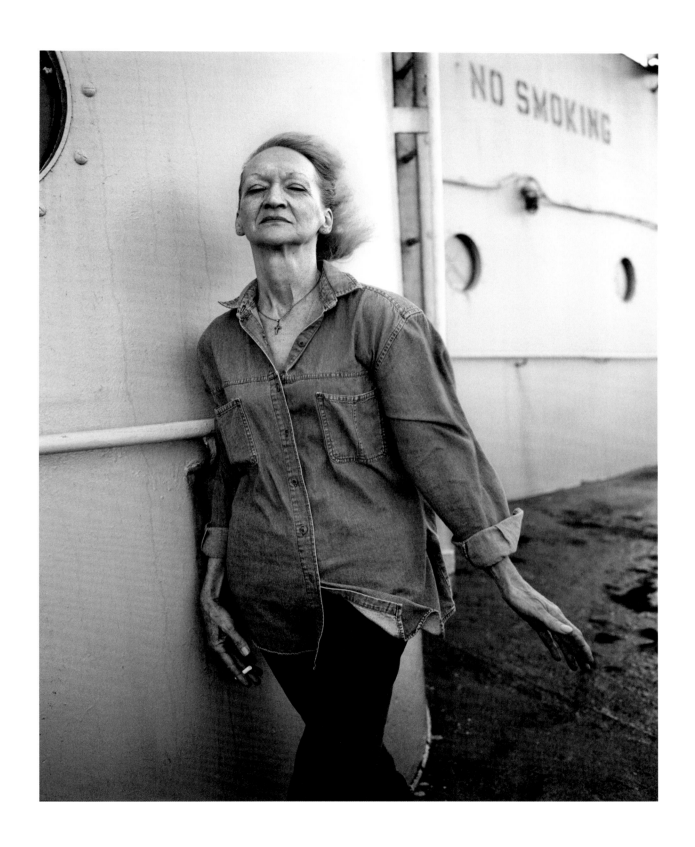

June Emerson, Assistant Cook

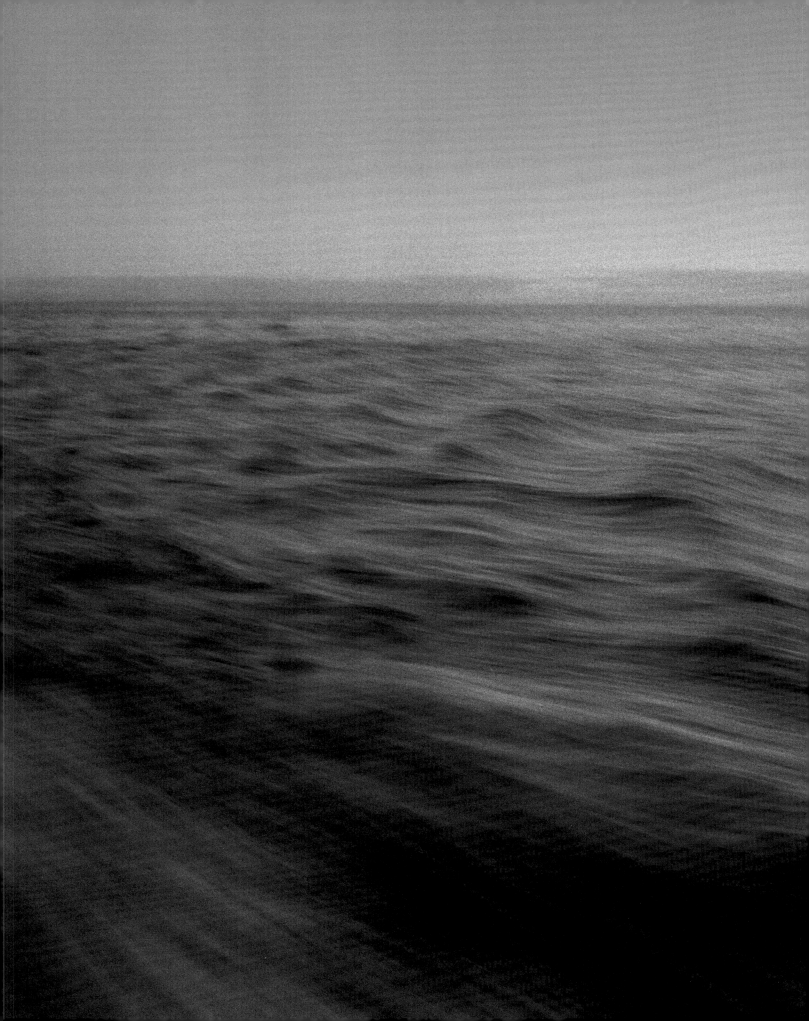

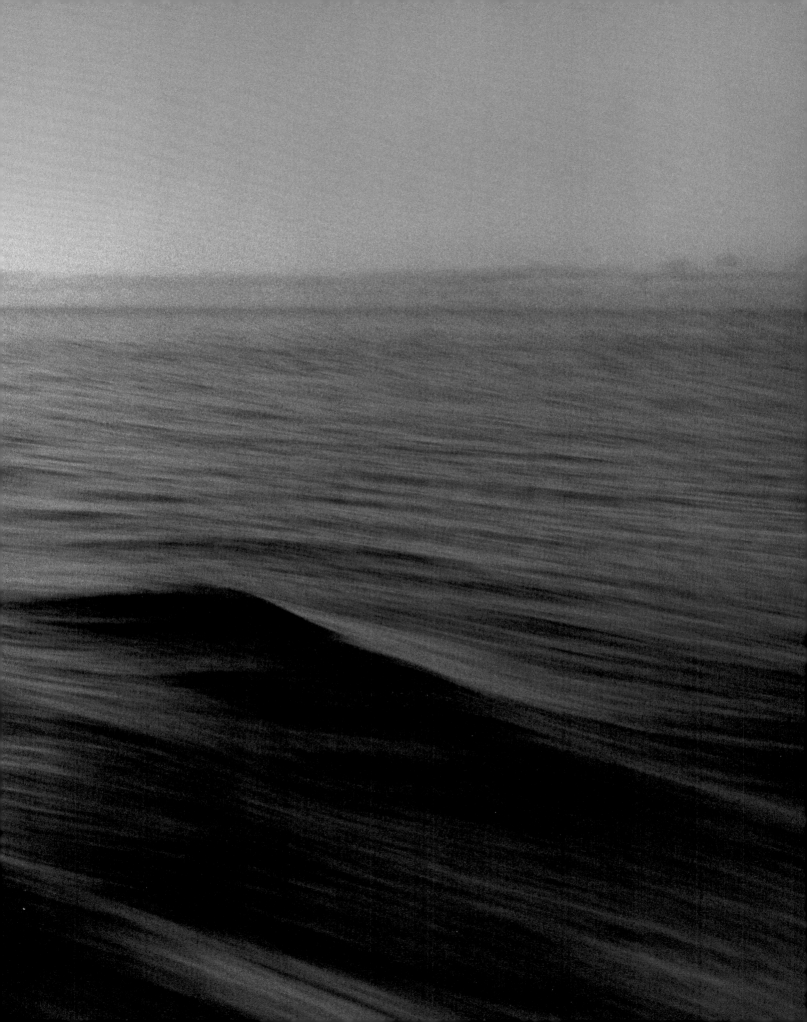

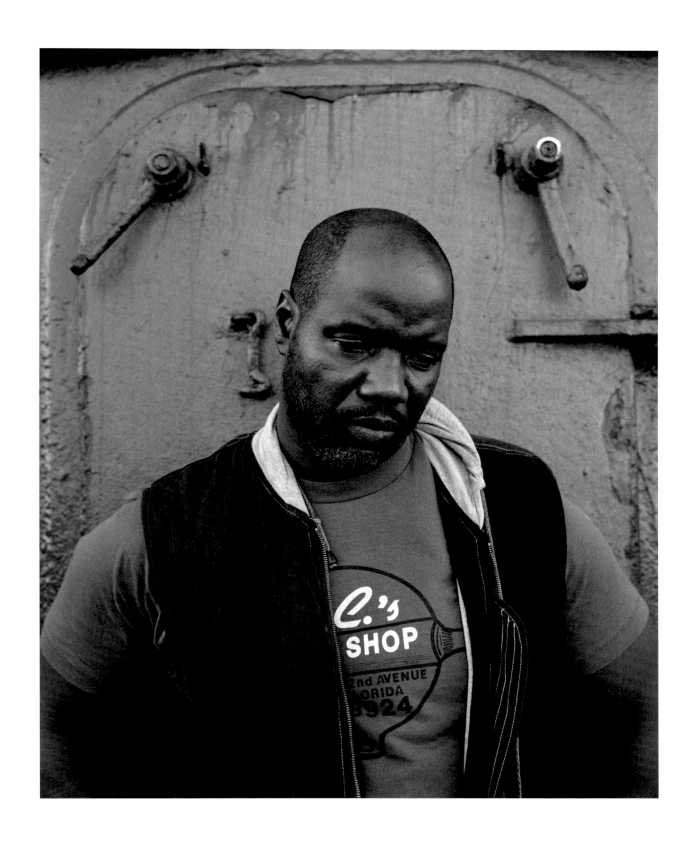

Harry Joe Fluker, AB Seaman

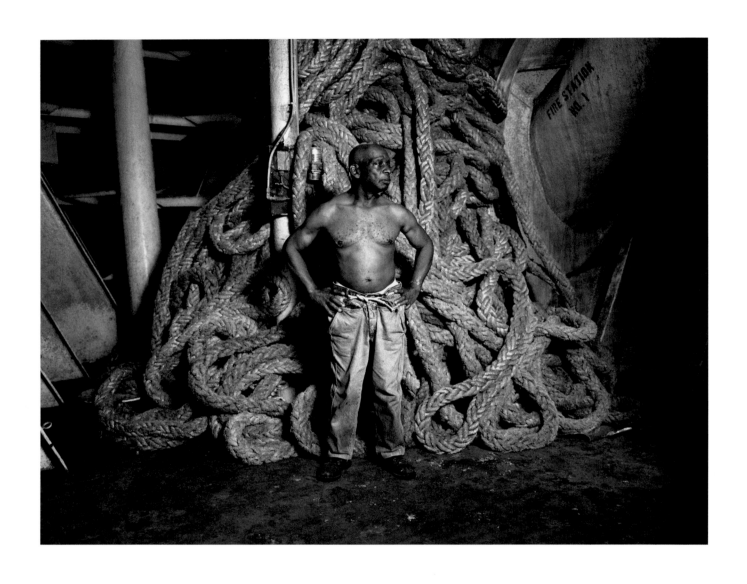

'Papa' John Wallace, Bosun

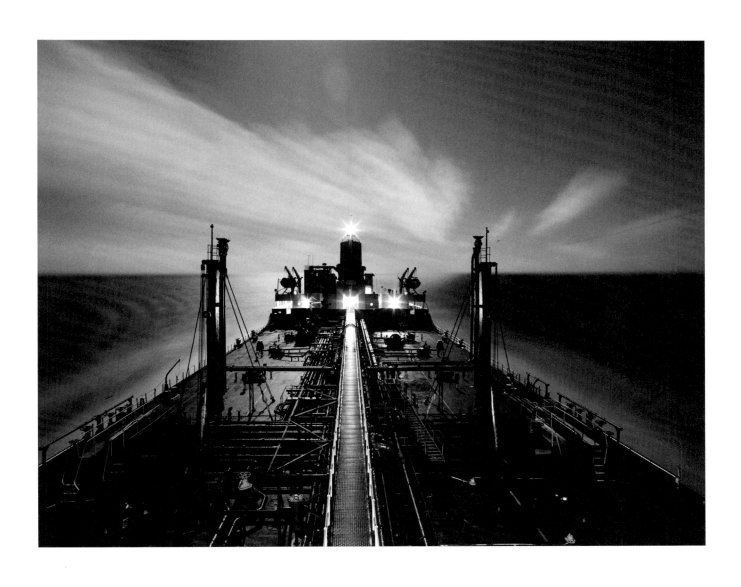

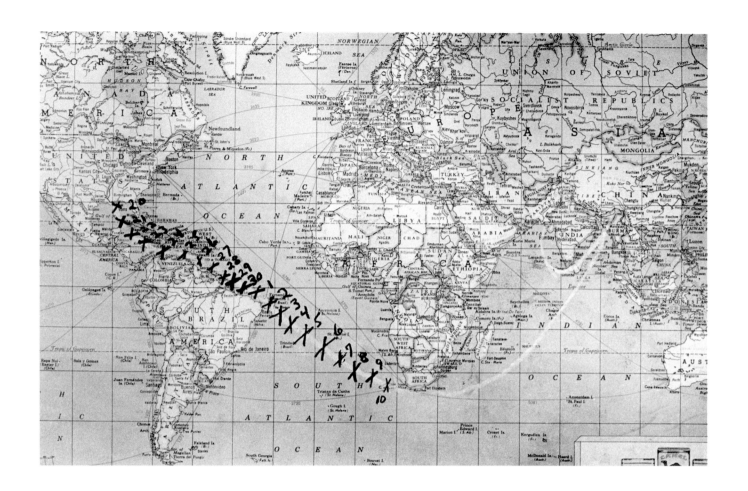

Marking time, Engineers' Office

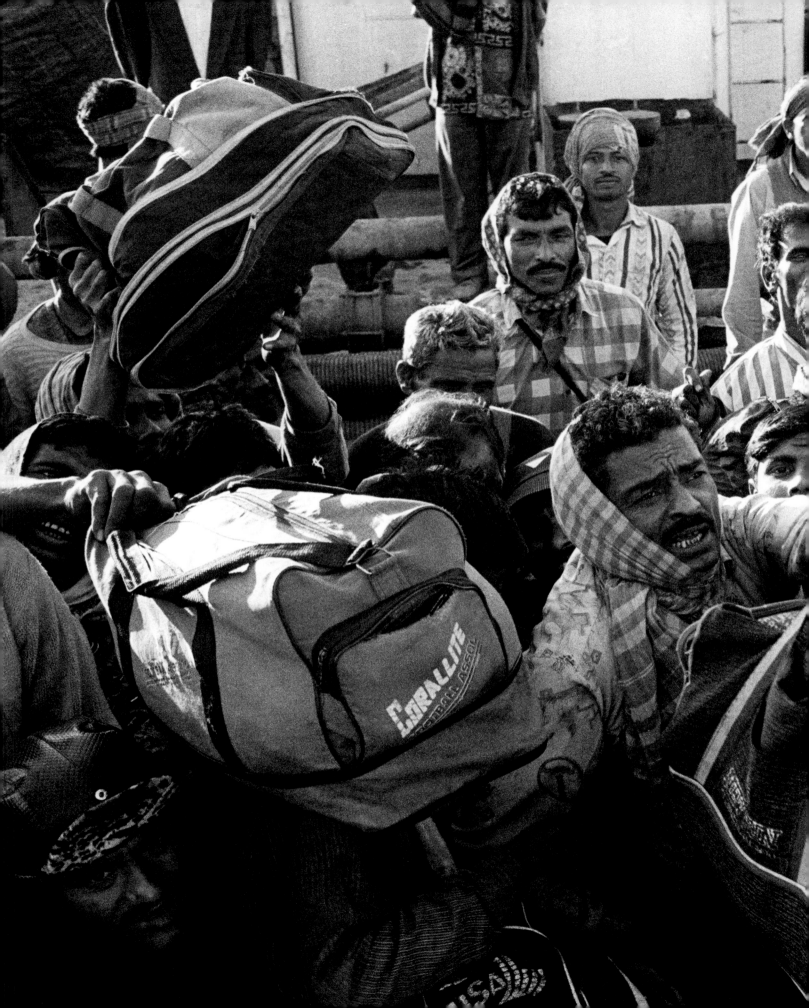

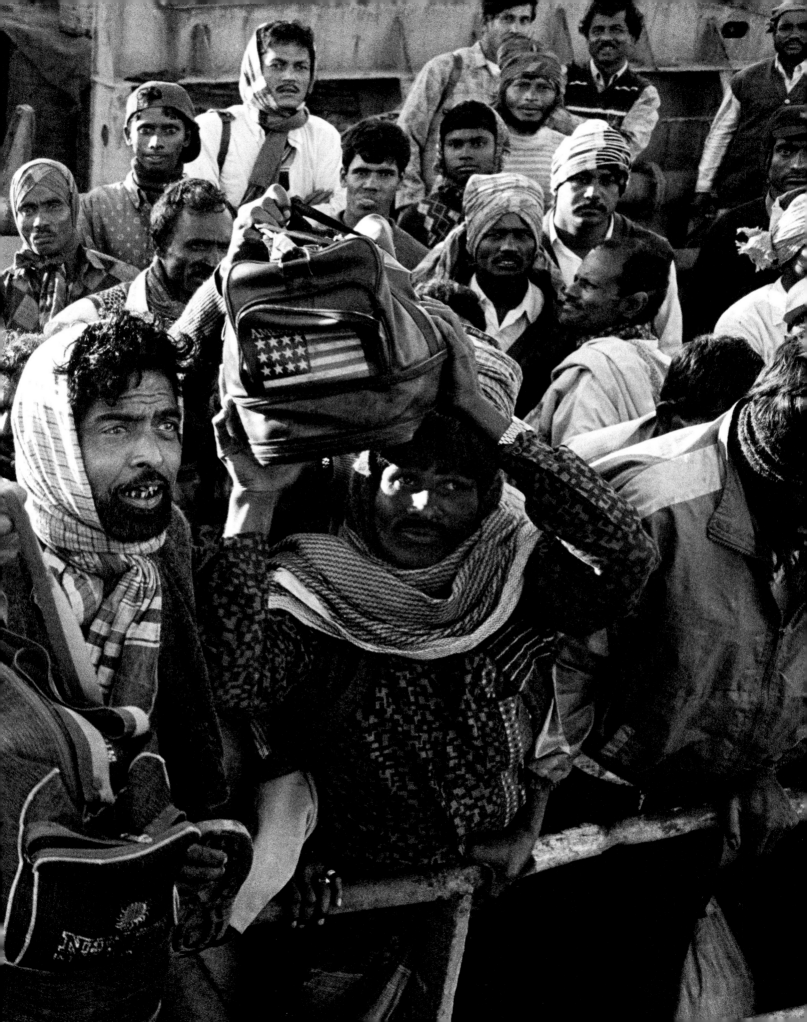

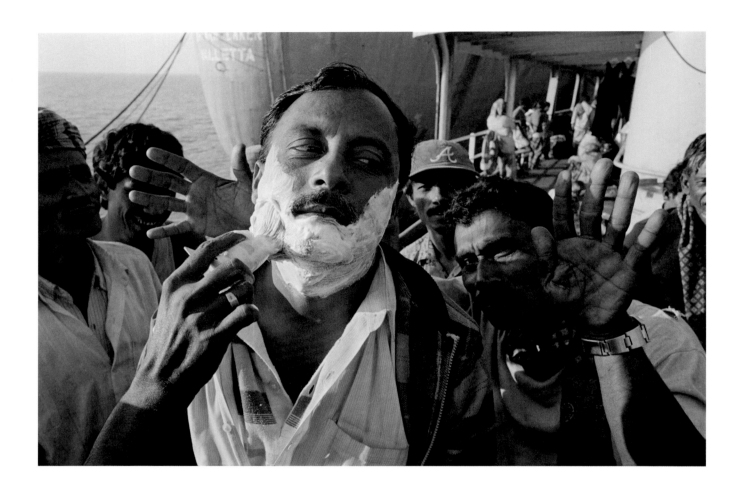

Previous page:
Longshoremen board the *SS Minole* at anchorage off Kutubdia Island, Bangladesh, December 27, 1997

This page:
The bazaar on the fantail

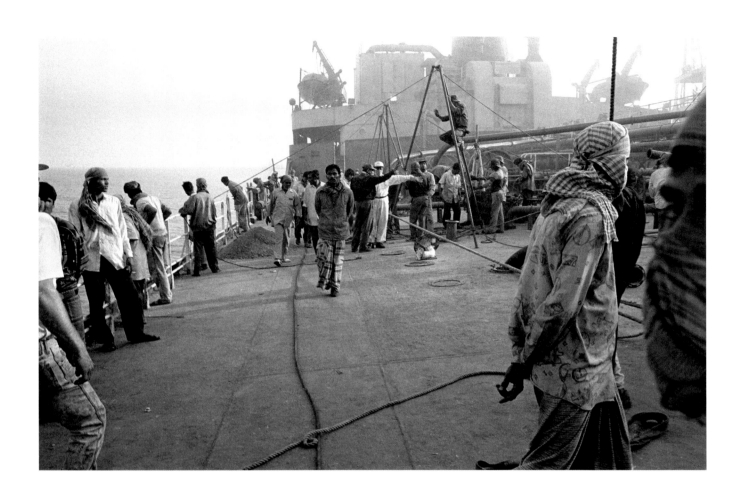

The unloading of the ship's cargo

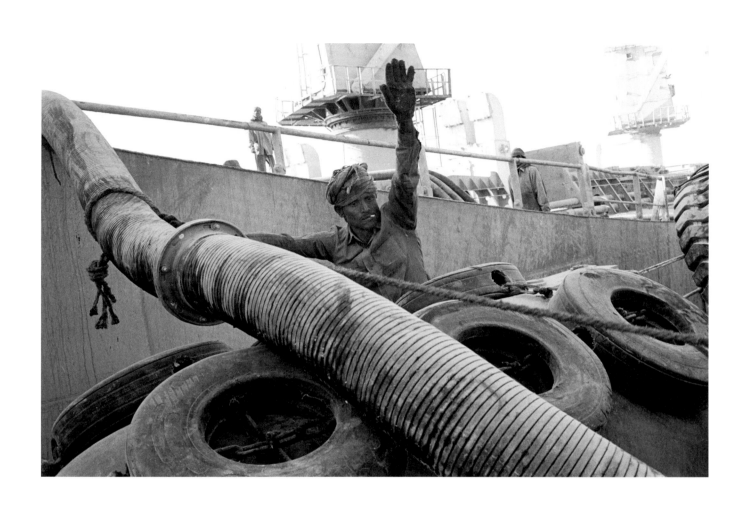

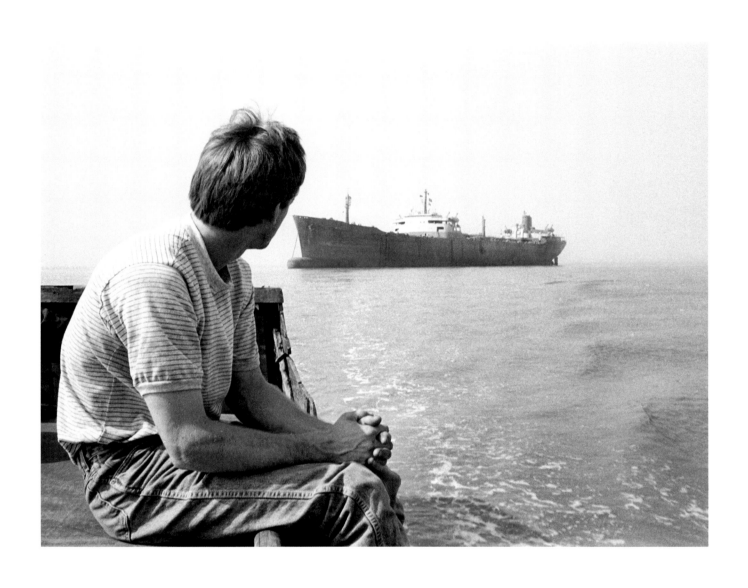

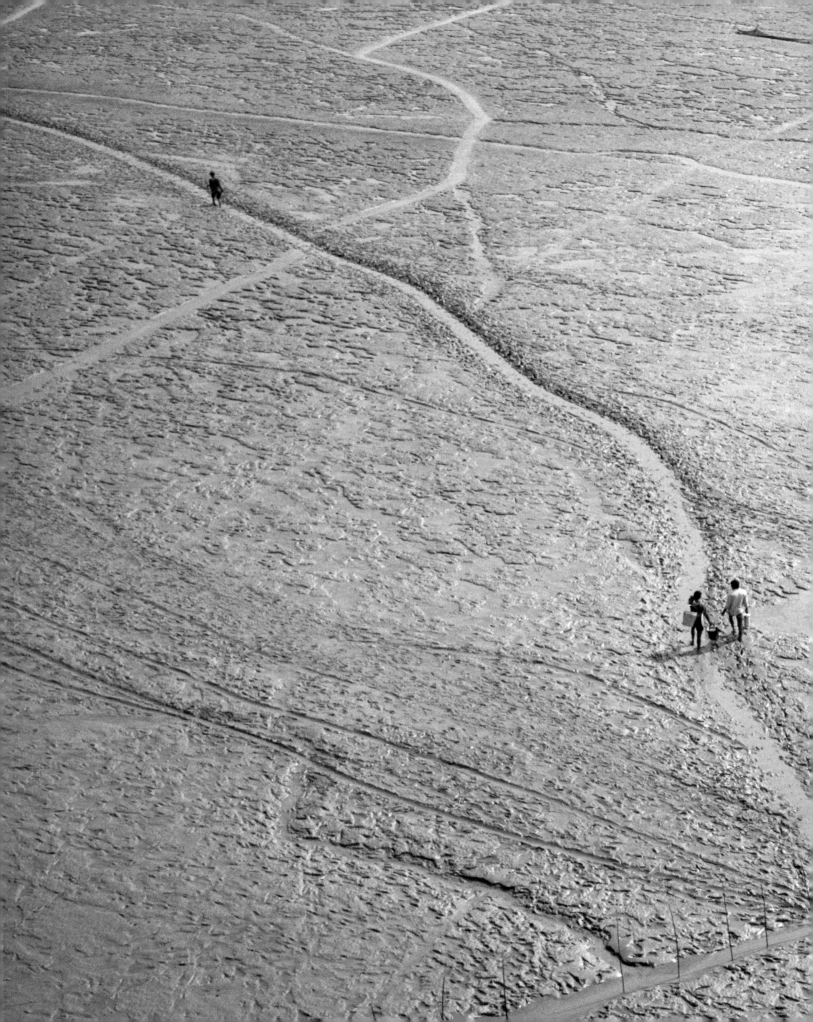

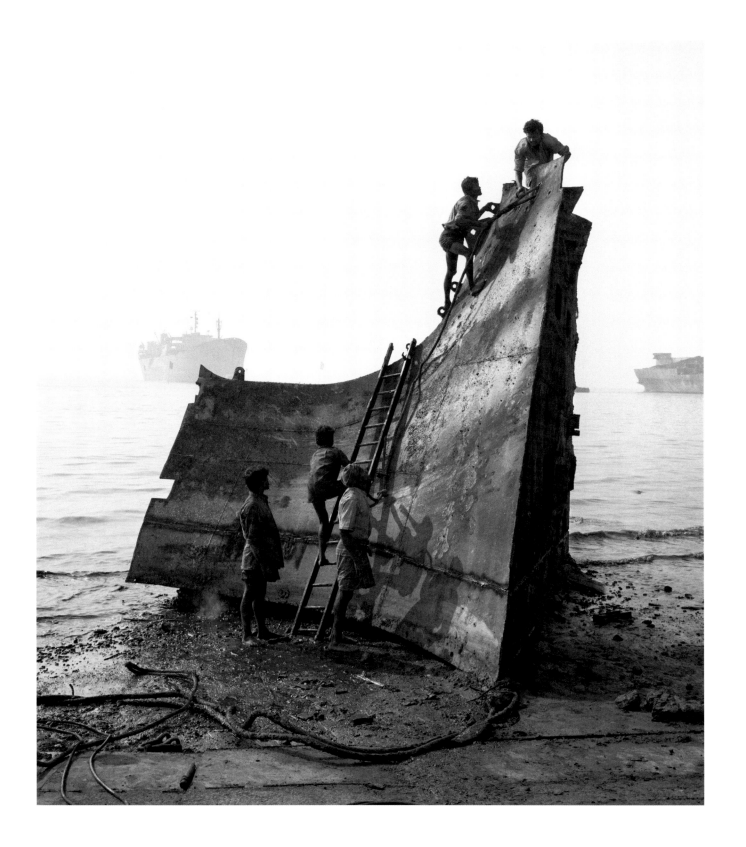

The beaching of the *SS Minole*, January 14, 1998, 2:20 PM, Lalbagh, Bangladesh

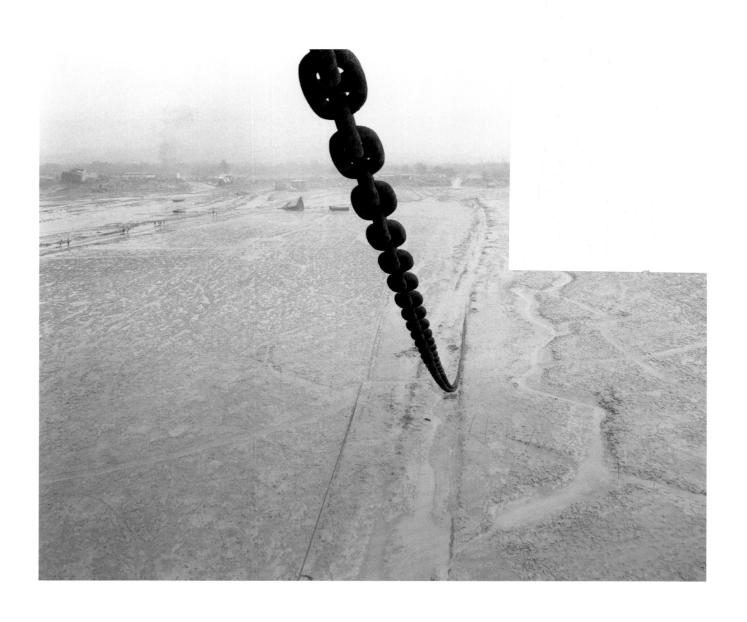

Anchor chain paid out

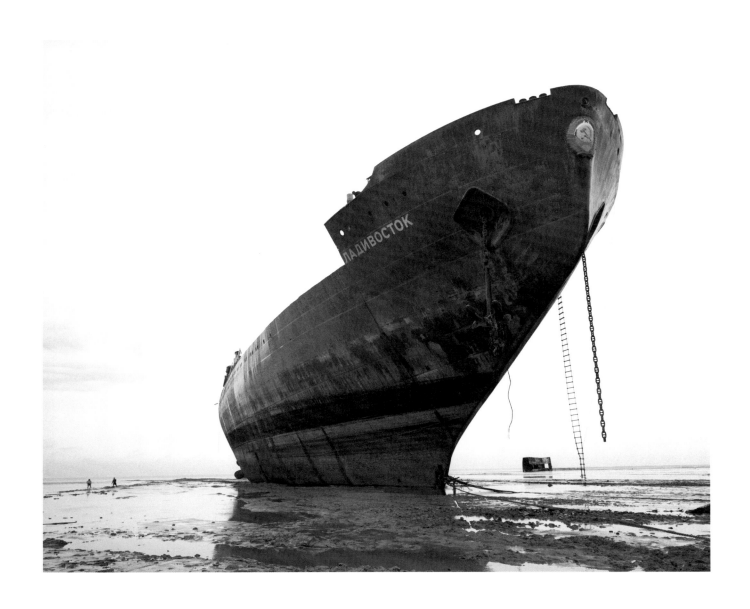

Beached former Soviet icebreaker

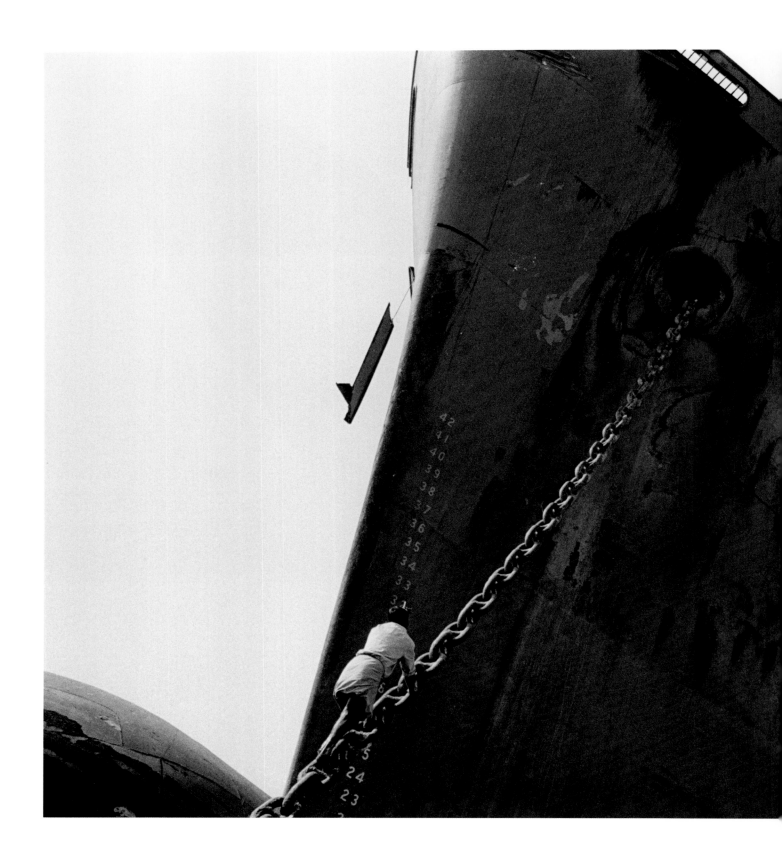

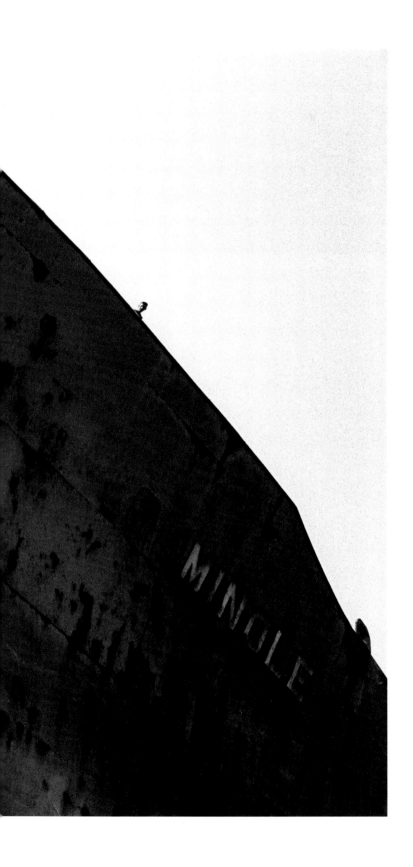

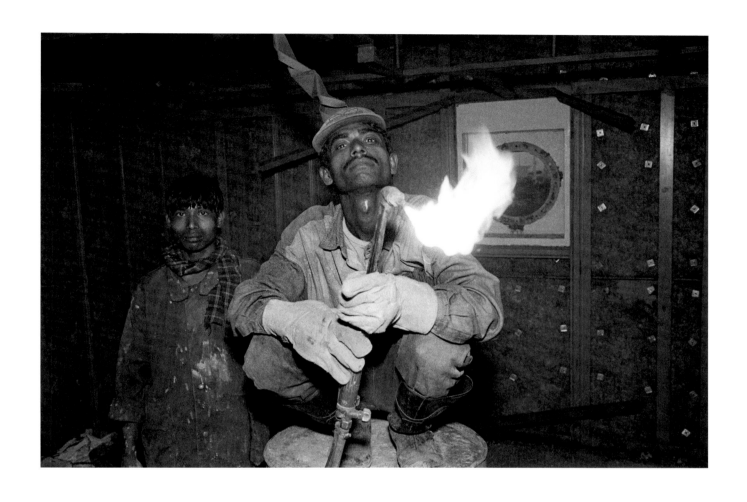

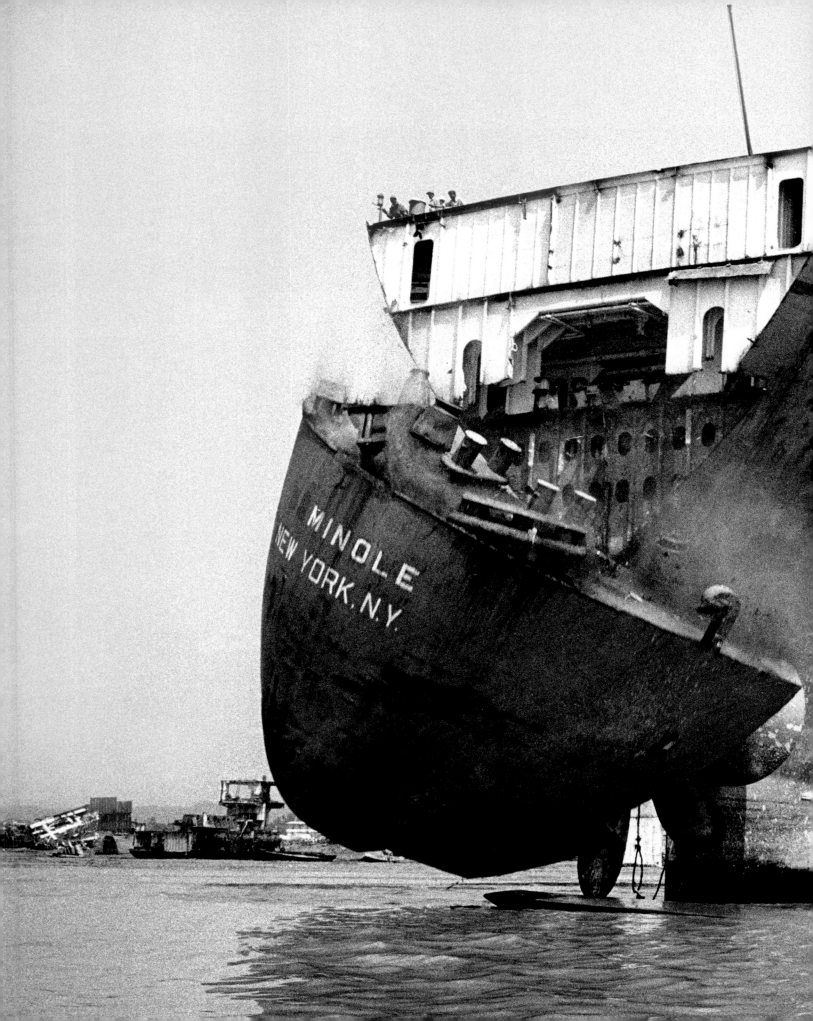

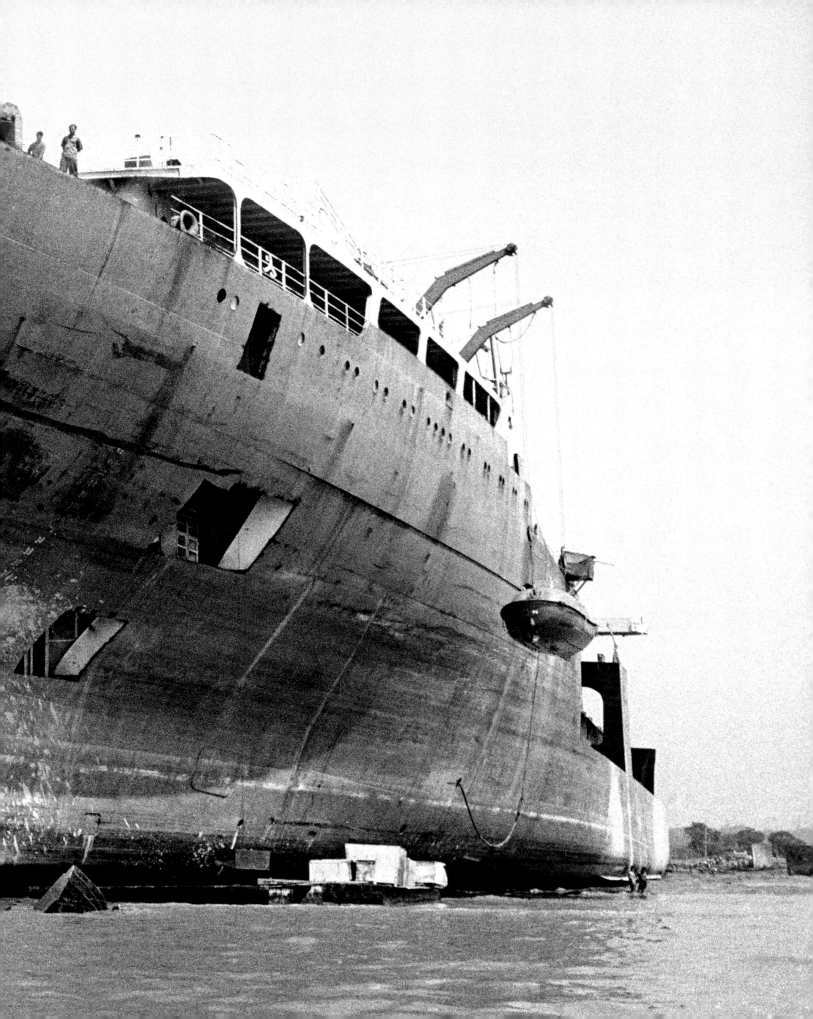

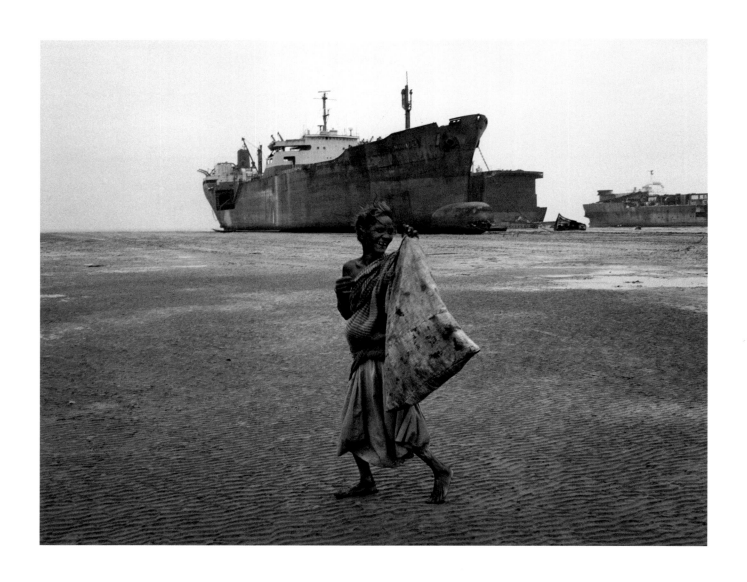

Beggar woman

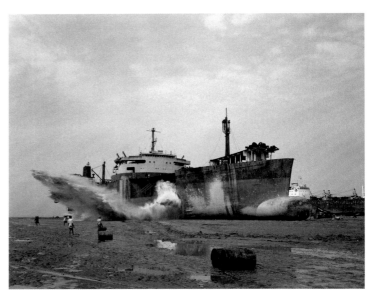
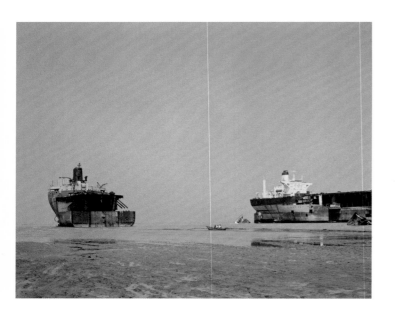
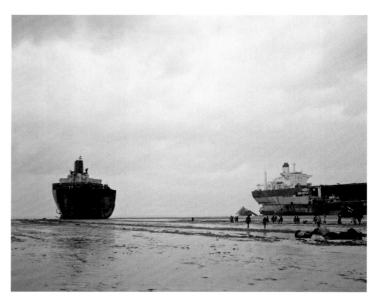

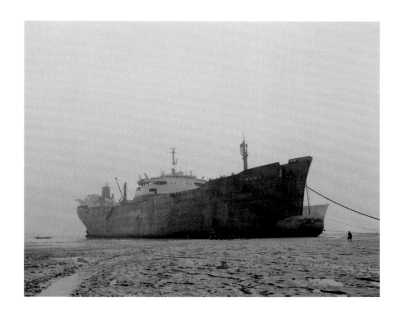
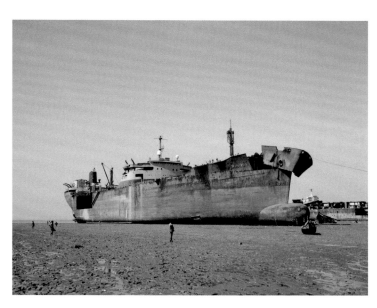
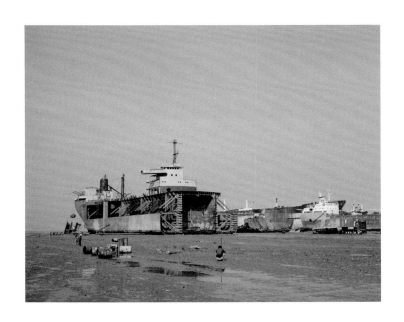
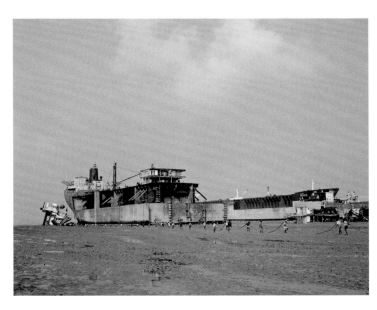

The complete breaking of the *SS Minole*: January 14 – June 1, 1998

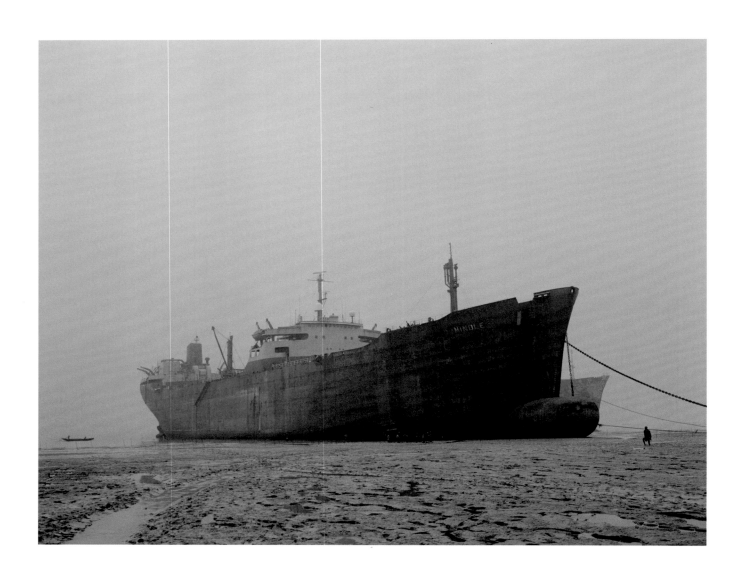

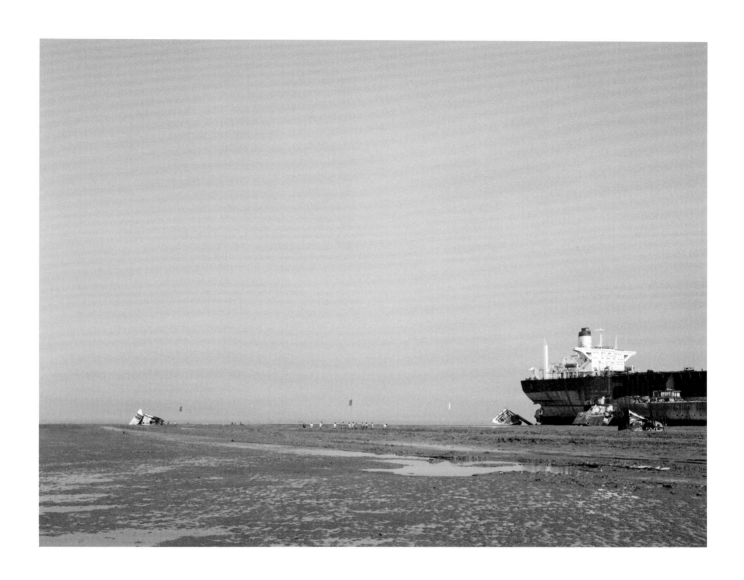

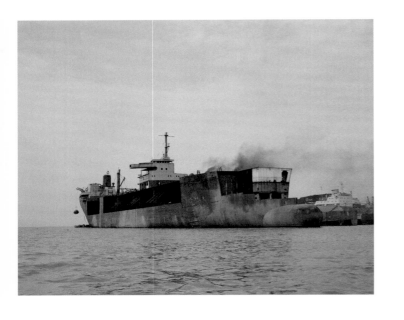
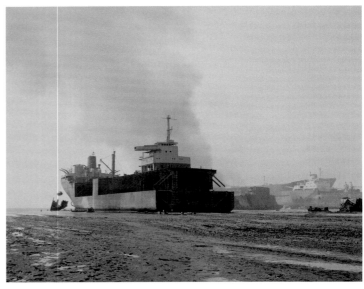
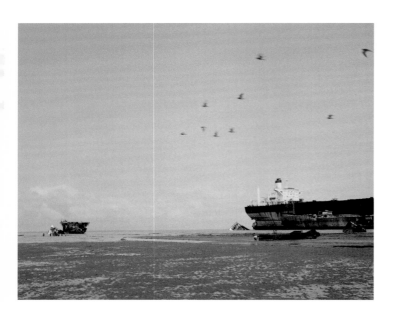
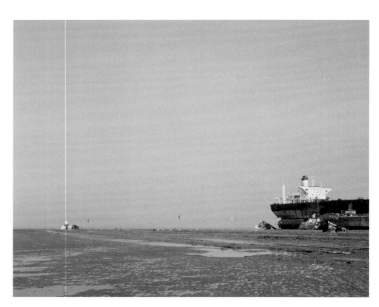

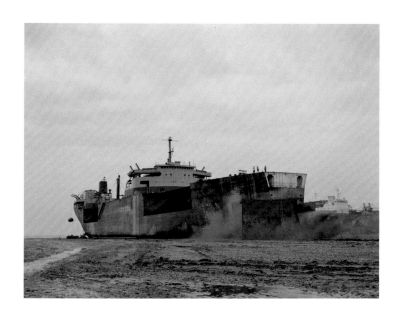
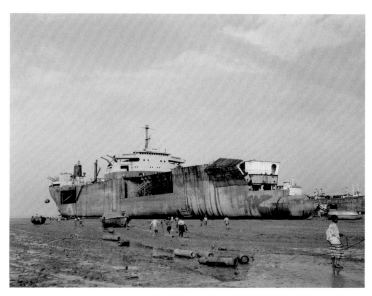
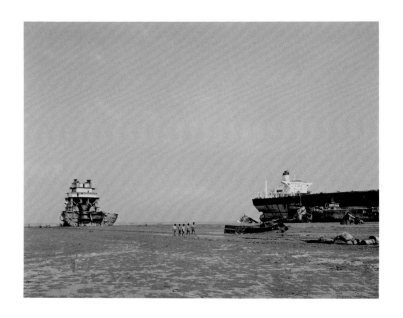
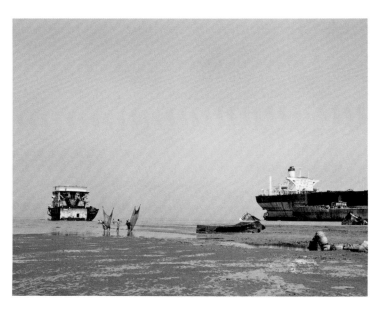

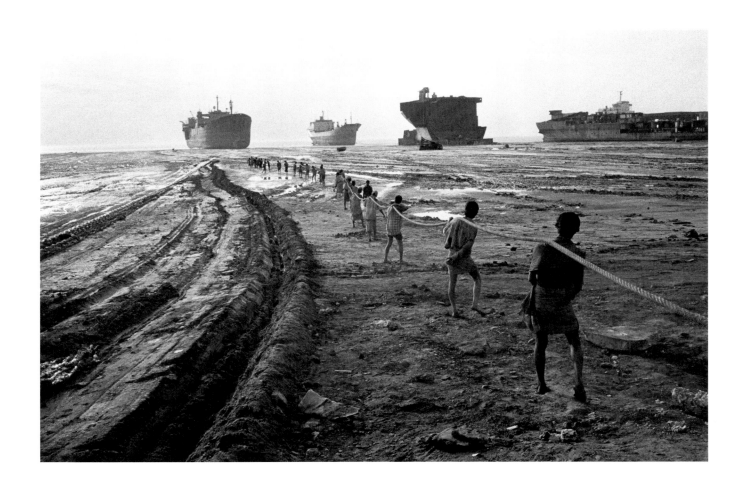

'Wire carriers' move cable to the ship to retrieve a felled chunk

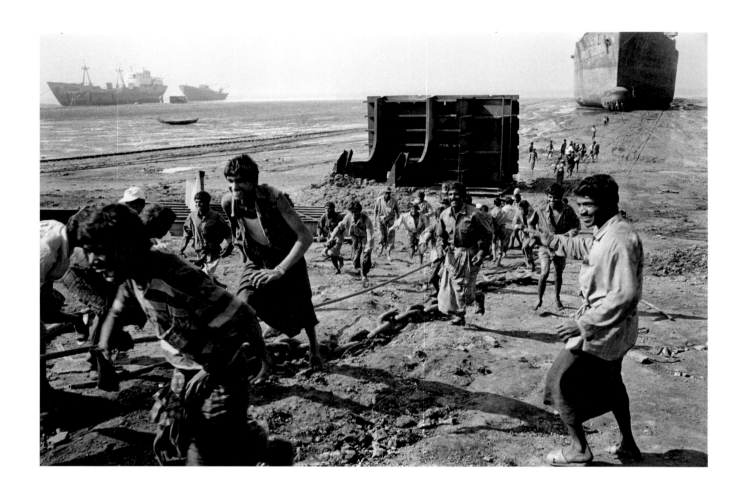

Wire carriers

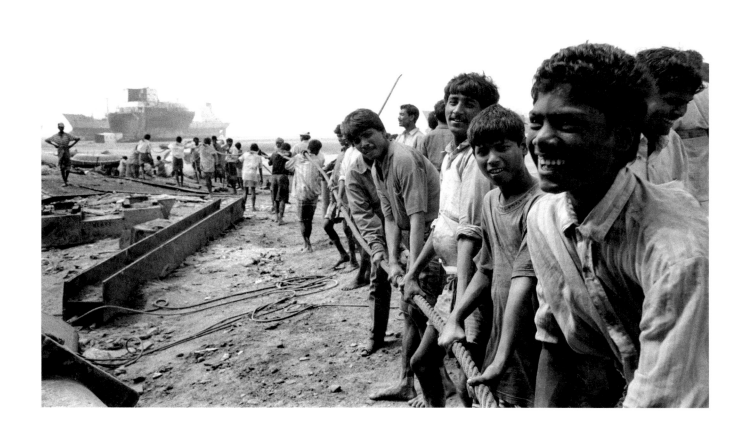

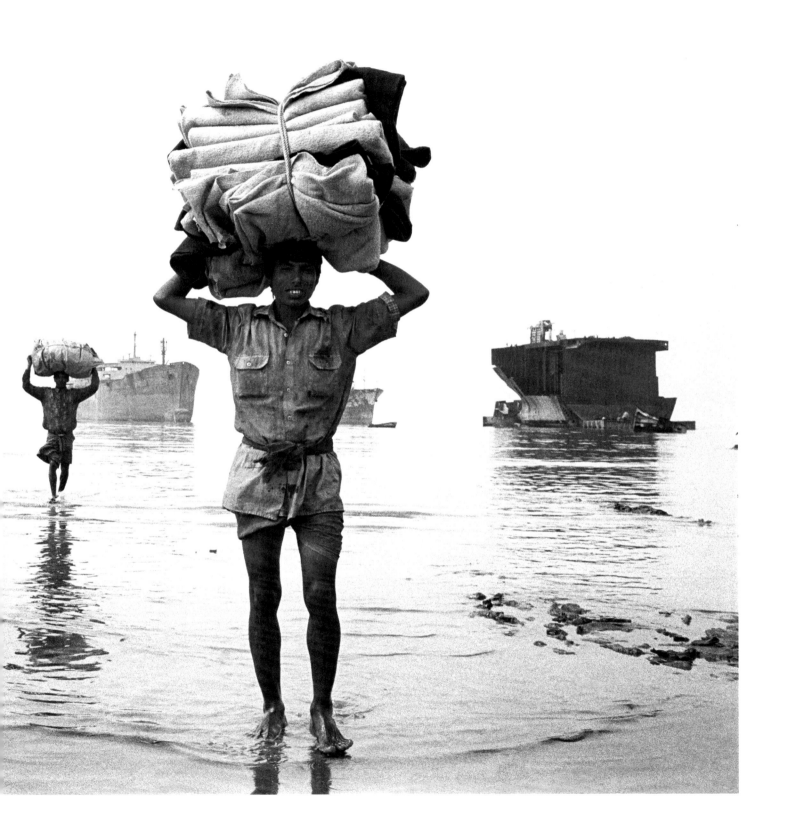

Offloading the ship's contents

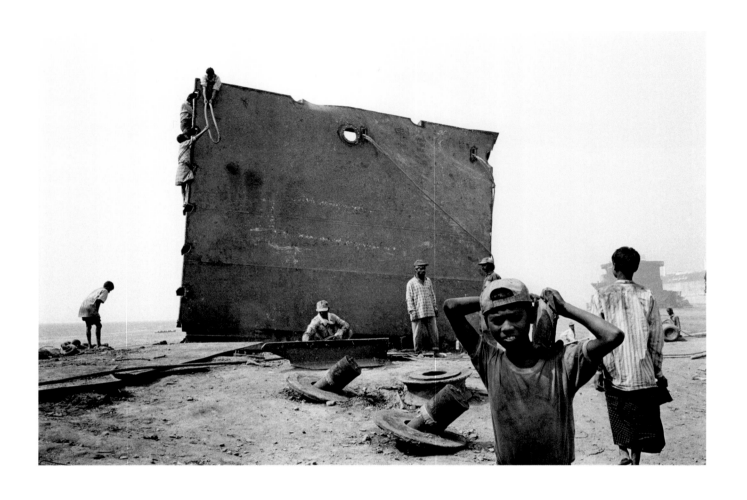

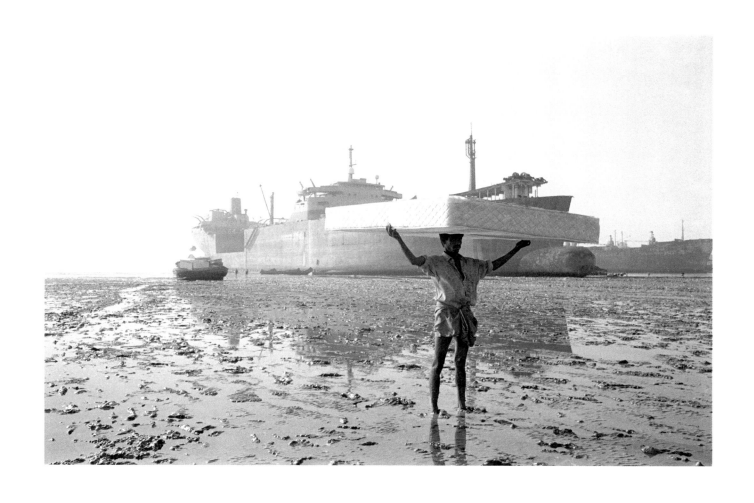

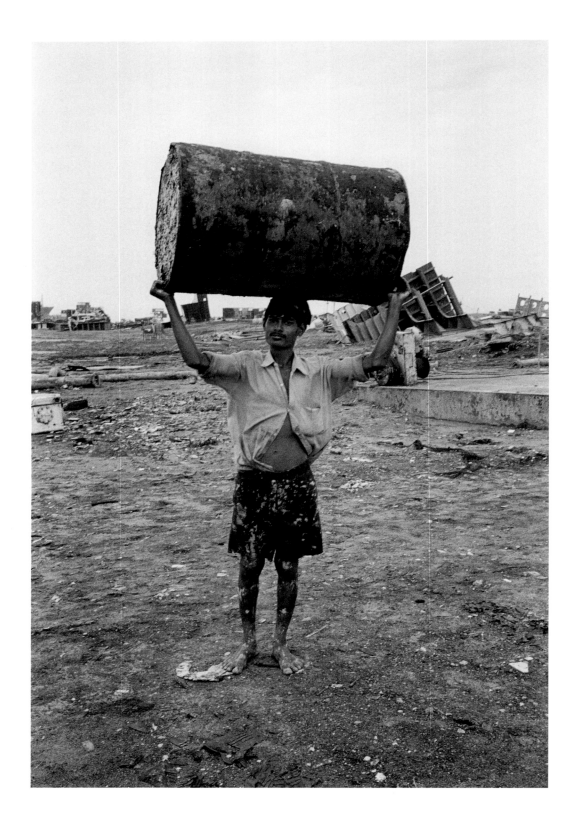

Oilman

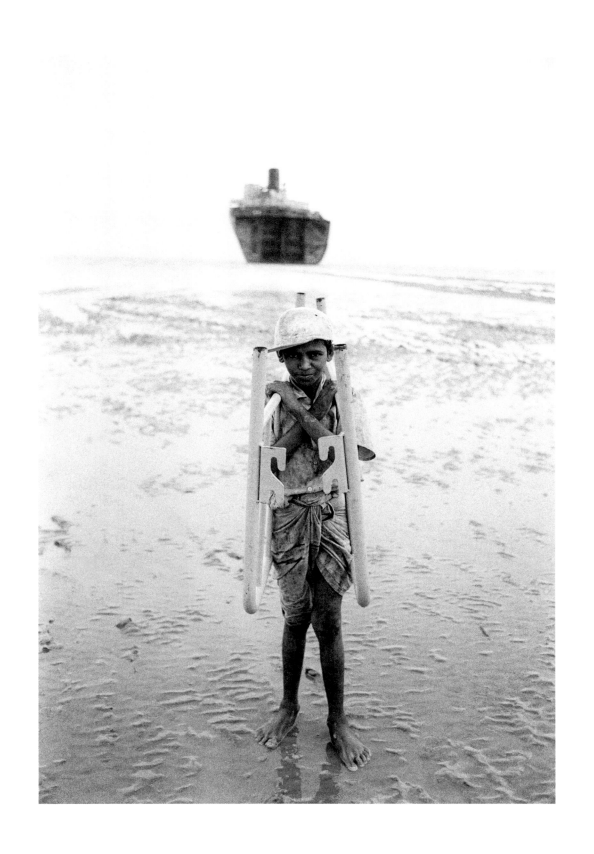

Kholil, age 11, carries a bedframe

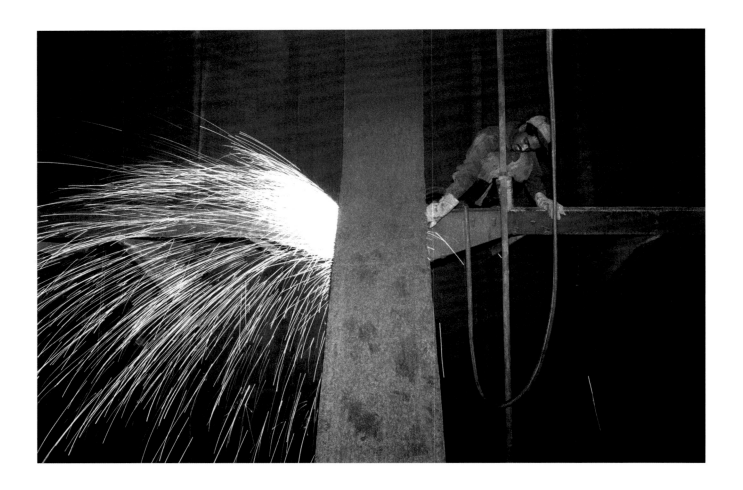

Cutters

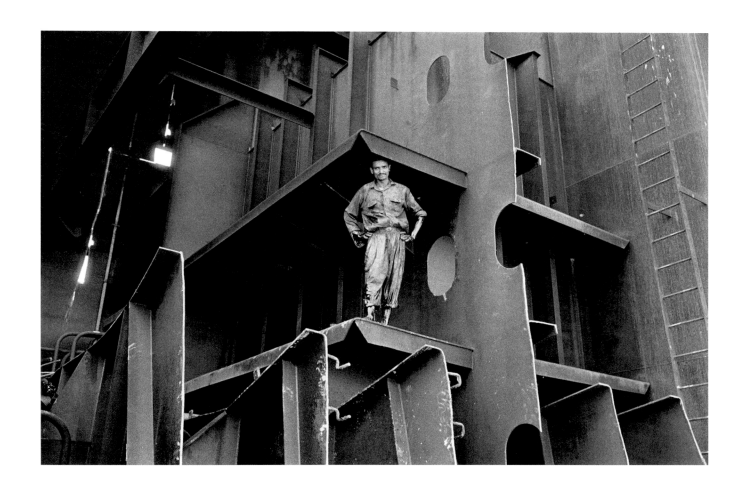

The former crew's mess

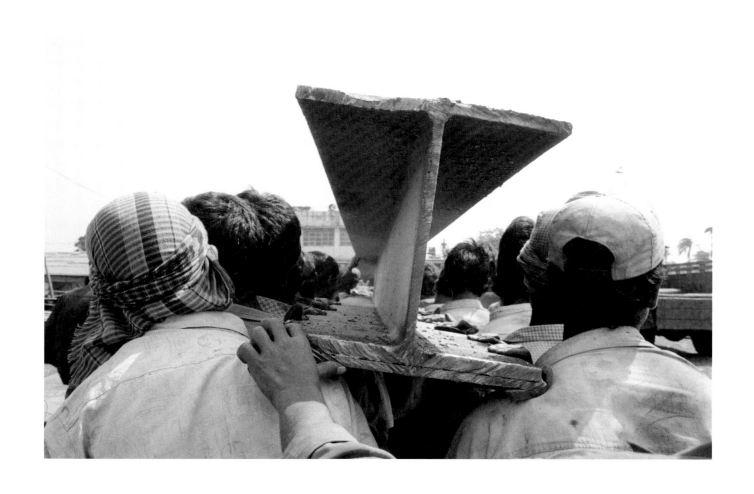

One-ton I-beam

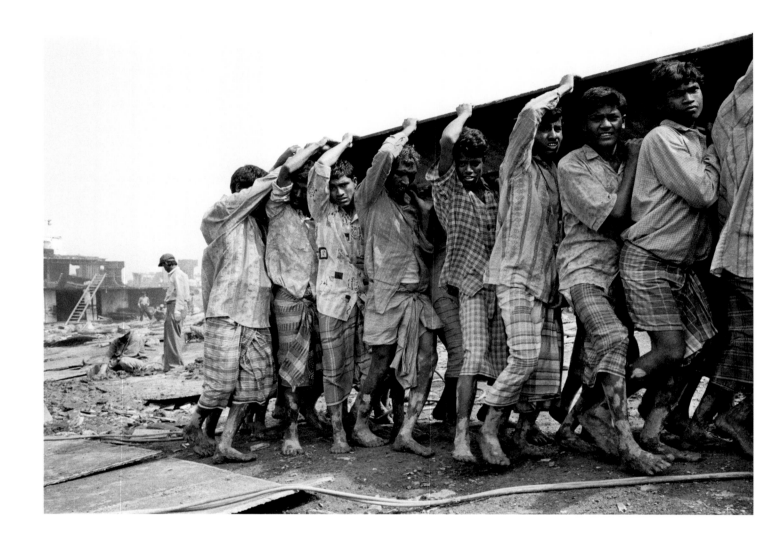

Loaders: frieze

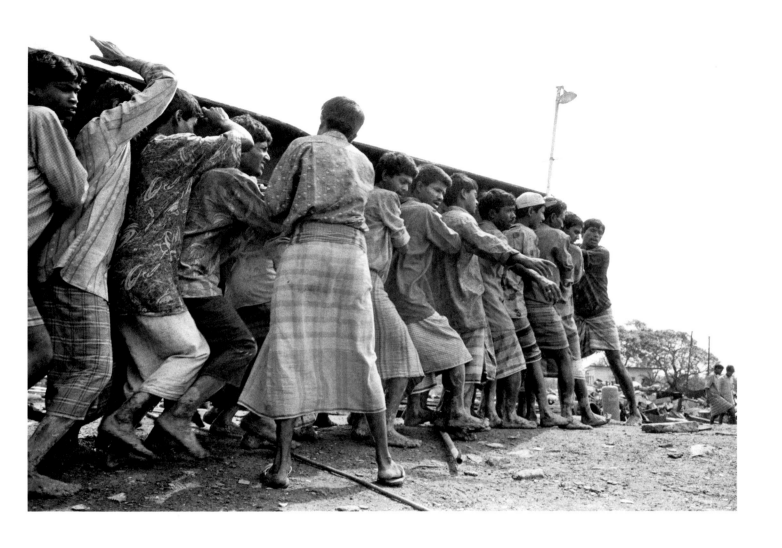

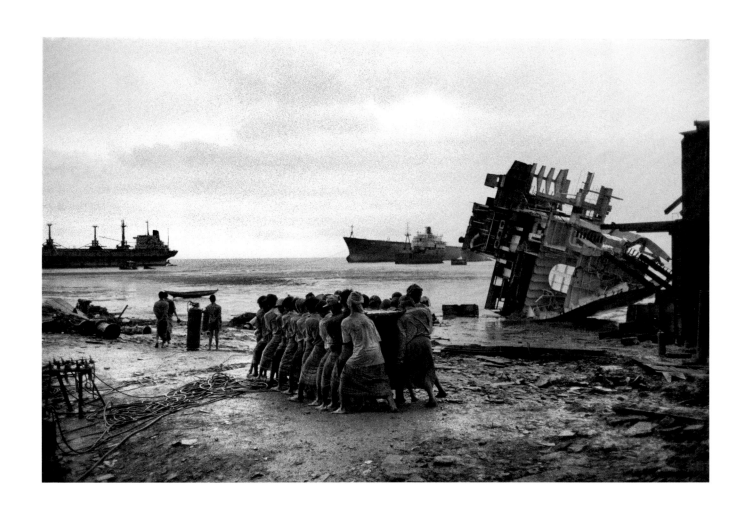

Loaders, monsoon

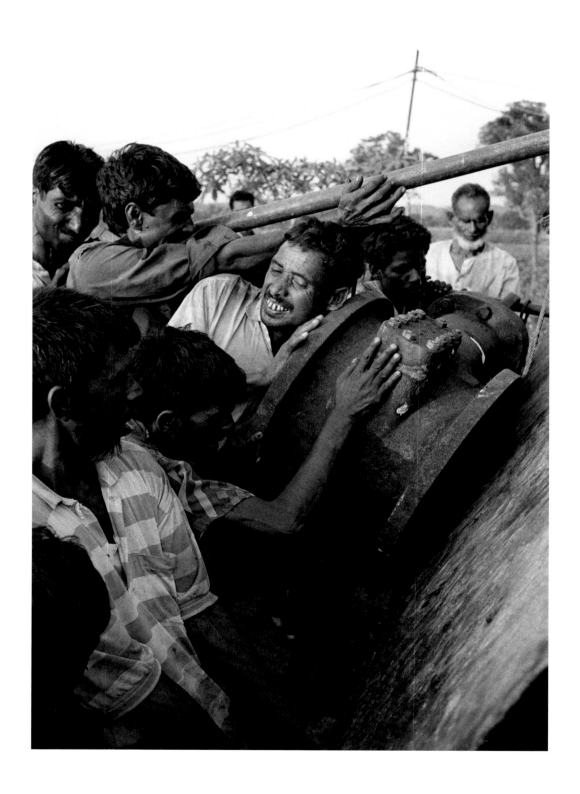

Lifting a several hundred kilo valve onto a cargo truck by hand

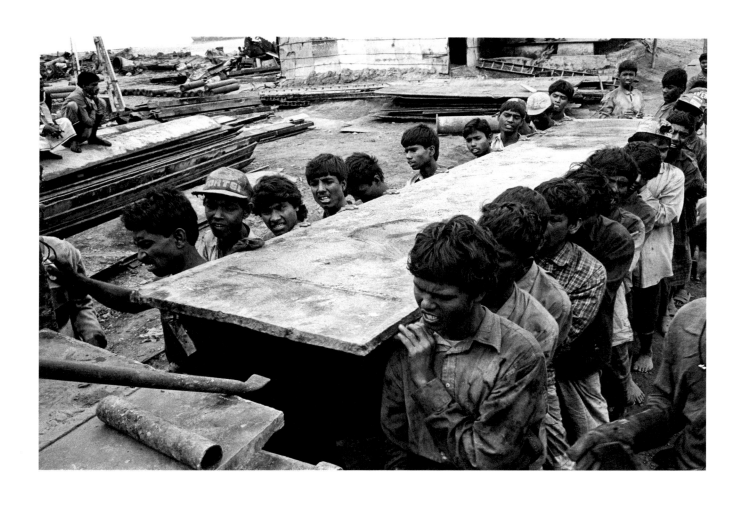

Loading cut steel plate onto a cargo truck

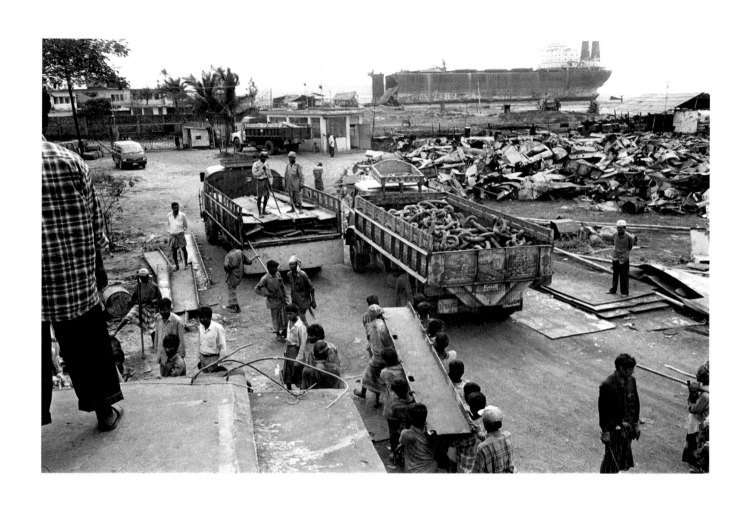

Loading area, shipbreaking yard

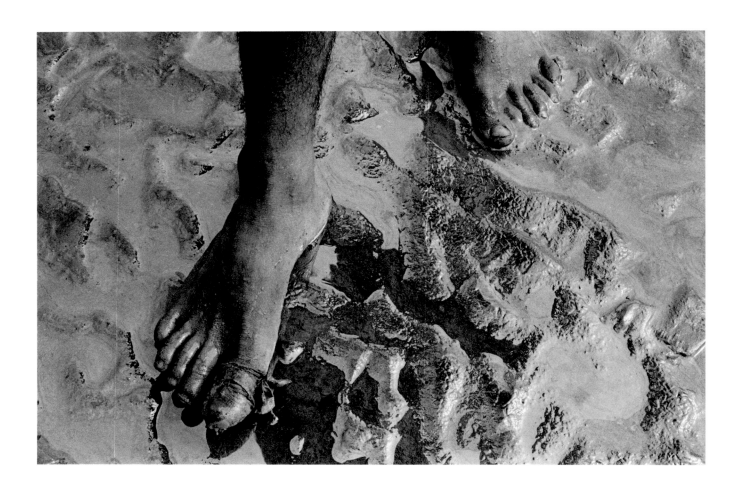

Injured workers

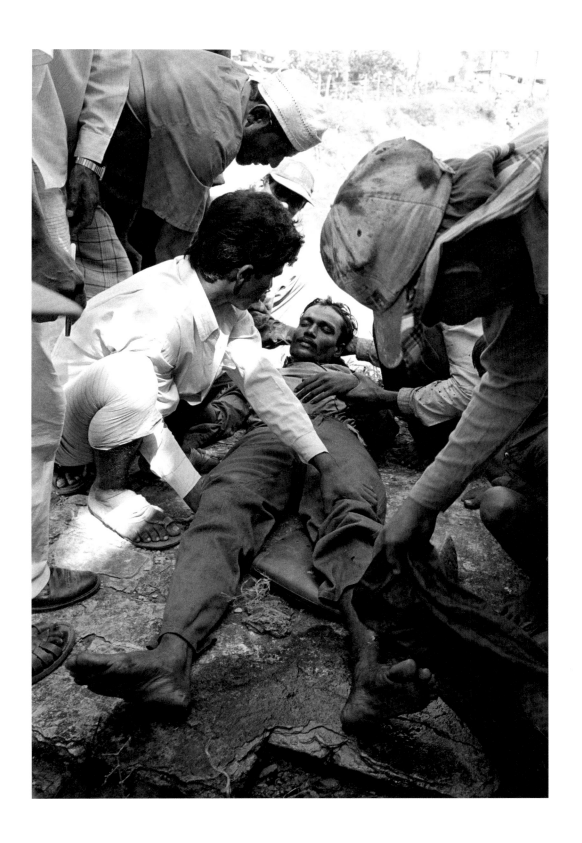

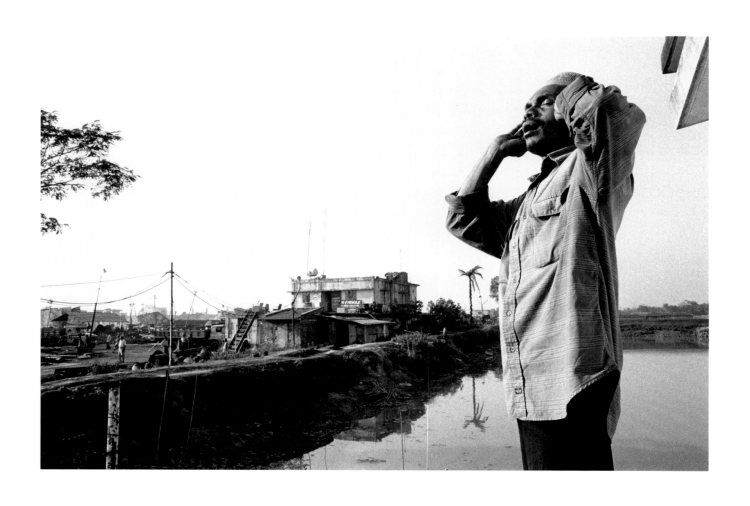

Call to Asr, the afternoon prayer

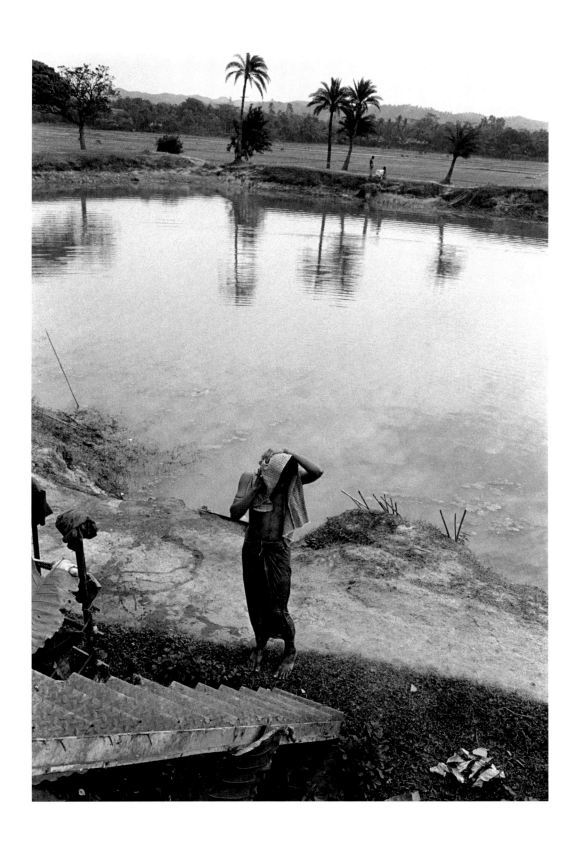

Drying off at the end of the day

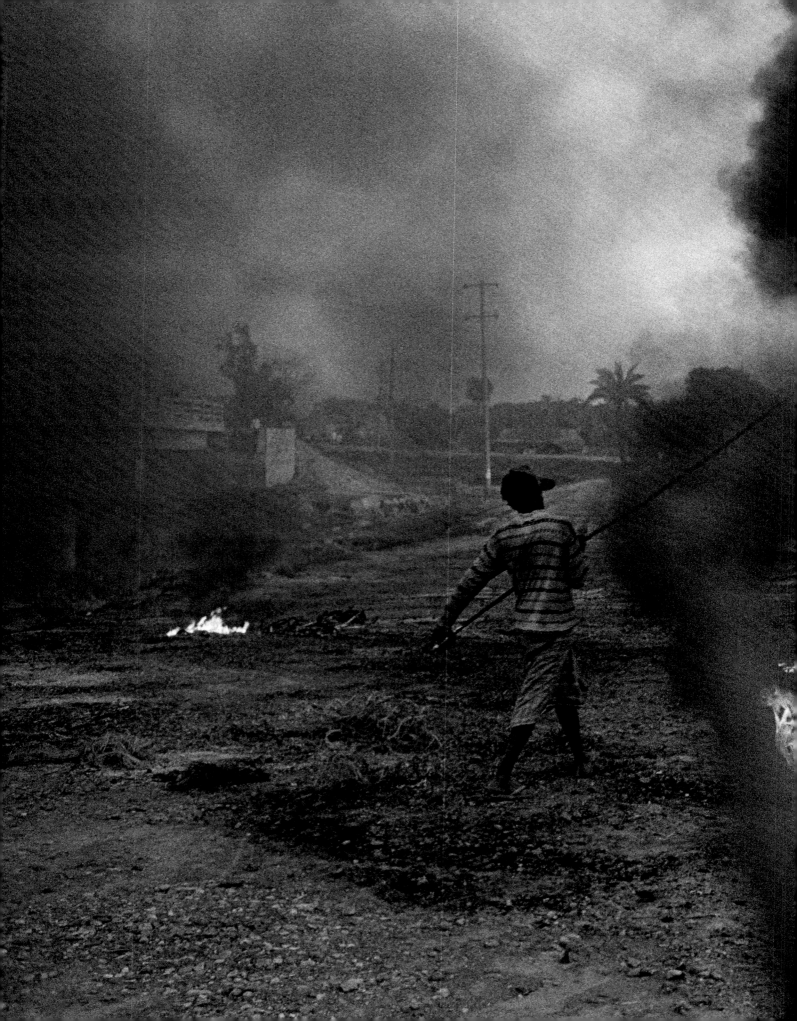

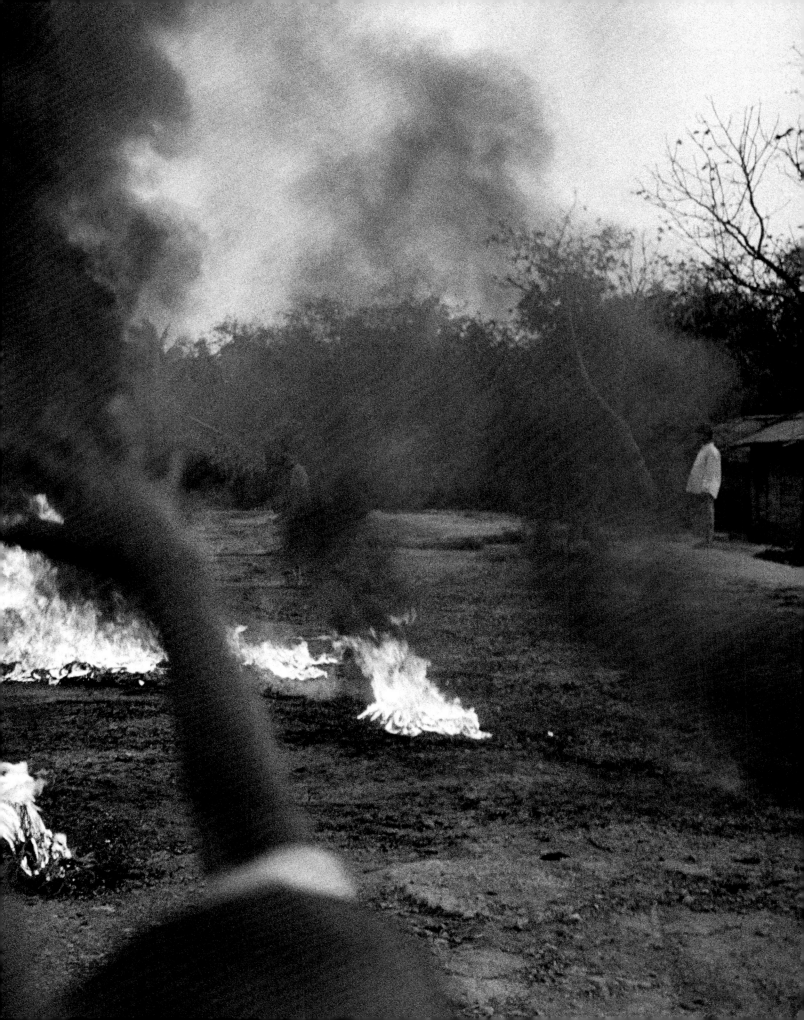

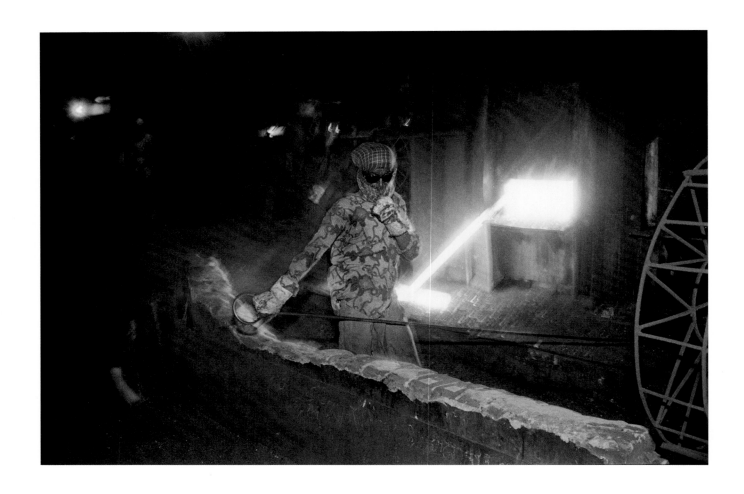

Previous page:
Burning rubber casing off copper wire

This page:
Kabir Steel Rerolling Mill No. 2, Kadam Rasul

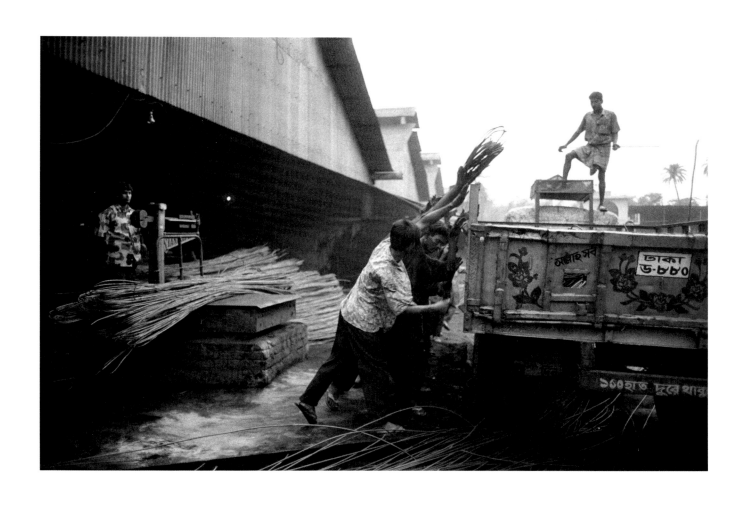

Loading rebar onto a truck

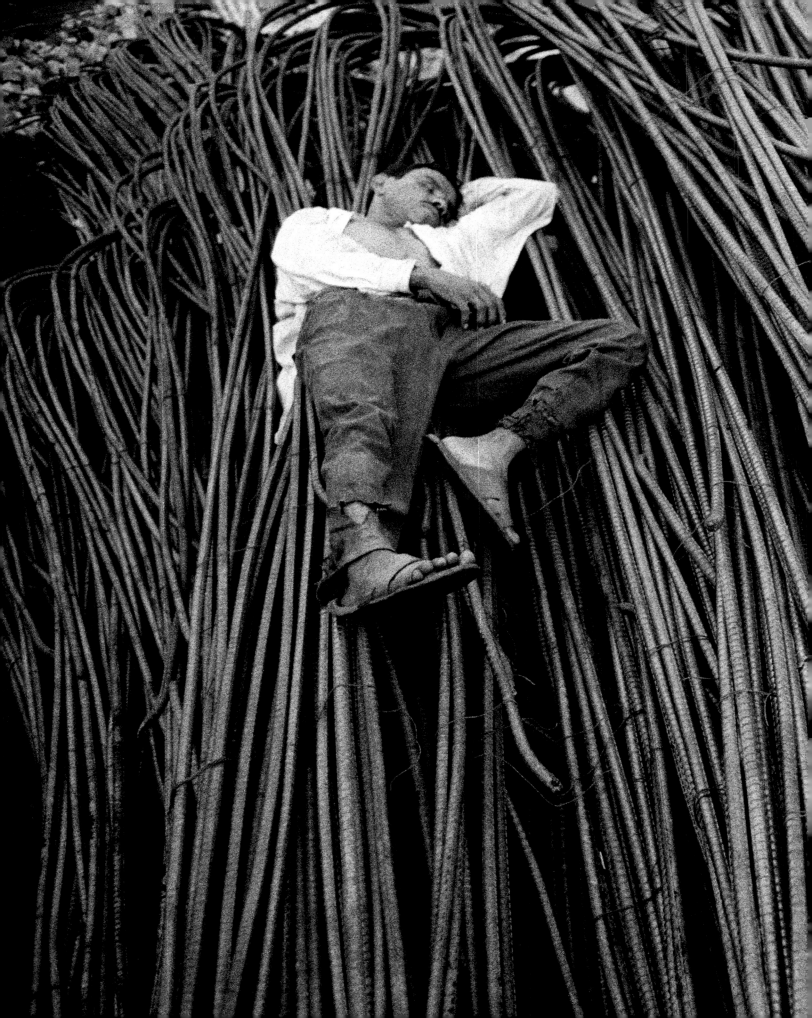

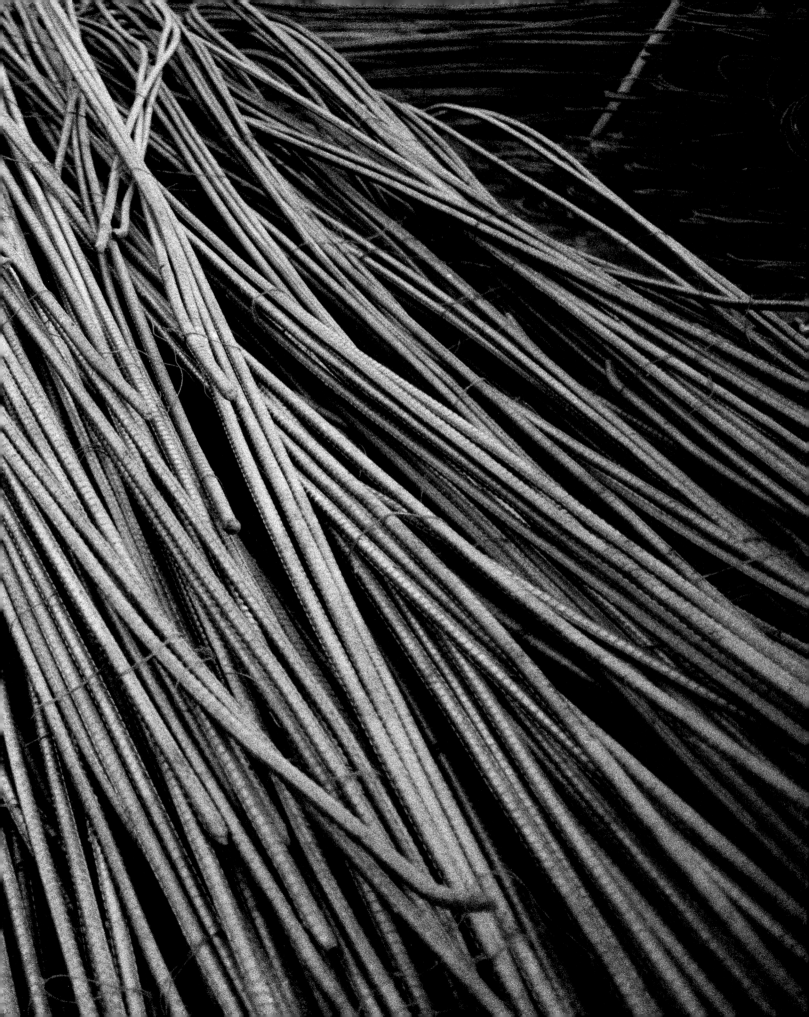

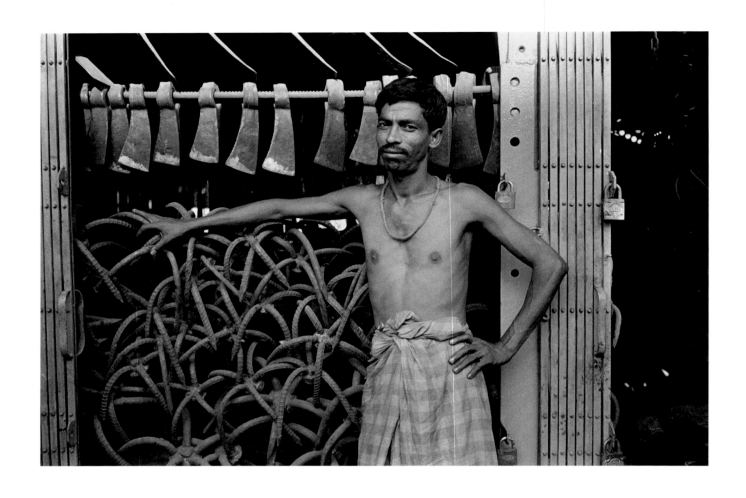

Previous page:
Cooling rebar, end of the night shift

This page:
Rebar anchor manufacturer, Patterghatta, Chittagong

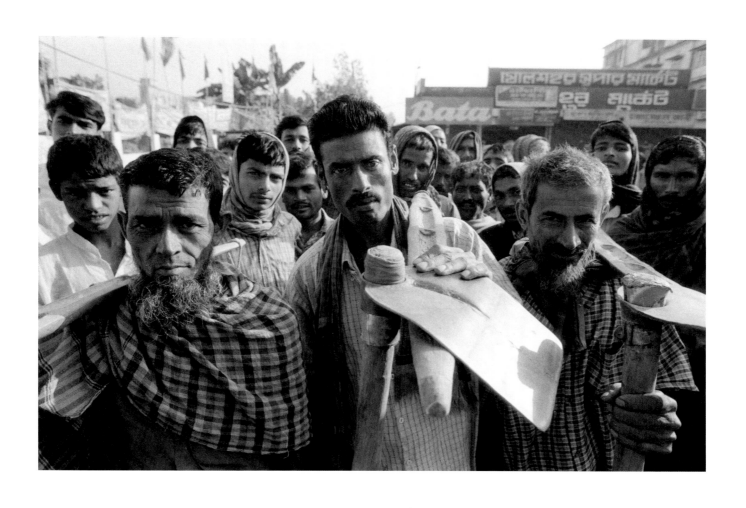

Day laborers (shovel blades made from recycled ship steel), Chittagong

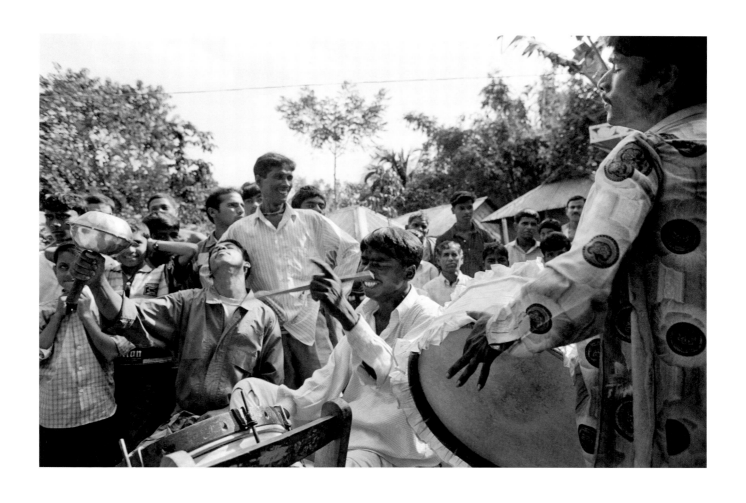

Wedding band (drum tensioners made from rerolled steel rod) Pencheverri, Bogra District, Bangladesh

Crow's nest made entirely from wire stolen from the shipbreaking yards

When the steamship *Minole* pulled into the dock in Port Allen, Louisiana on the night of November 3, 1997, she had already been several ships: formerly the *Seminole*, once the *Mobil Meridian*, and originally the *Stanvac Meridian*. She was one of Mobil's longest running vessels, and its sole remaining ship under the U.S. flag. In thirty-six years of service, she had logged millions of miles transporting countless barrels of petroleum products around America and across the world. She had been a vessel for many things, for many people, and to many places.

Tying up would be routine to a ship with such a long history, yet maybe she sensed that this time was different. It was not the regular crew aboard; they had left her in Tampa for a new ship. They had walked down the gangway with only their belongings and some records. They had stayed for a while, told a few stories, and then they just drove off; that was it. This was a new crew from another company. They took her to an old, dilapidated dock in Violet, Louisiana, just south of New Orleans, where other ships lay idle and sleeping. There they scrubbed out her tanks to render her clean and gas-free. They removed some items which were taken to another ship. When they took out her wheel, maybe she overheard them say that it was too nice to leave aboard, such a big beautiful piece of wood, that it was only going to go to waste.

They had brought her to this port, one she had never visited before. It was not a refinery, but a grain dock. The next morning they began filling her thirty-three tanks with hard winter wheat, and it was then she knew that this time was different because it would be the last.

≈ ≈ ≈

The *Minole* was a ship that had outlived her time. She had to be sold out of the American merchant fleet because she was a single hull tanker that did not comply with the Oil Pollution Act of 1990. Passed in the wake of the infamous *Exxon Valdez* oil spill, this legislation mandates that all petroleum carrying vessels in U.S. waters must be double hulled by 2015 to reduce the risk of cargo spillage.

She would deliver this last load of 43,300 metric tons of grain to the government of Bangladesh as part of the U.S. Government's PL-480 "Food for Peace" program, and then she would be sold for scrap to a shipbreaker somewhere on the Indian subcontinent.

But she was a good ship. She was solid, and she still ran flawlessly. Everyone swore that she had a good number of years left in her, and her owners had tried everything to keep her running. It was a shame to see her go. It seemed unfair to the ship, which had worked so hard and so well, to be discarded this way; but at this point there was nothing that anyone could do.

≈ ≈ ≈

Several years later, aboard Mobil's replacement ship for the *Minole*, the *American Progress*, the *Minole's* original crew sang her praises to me. The ship had spent much of her life transporting crude oil from Alaska down to West Coast ports in Washington and California. In fact, for many years she held the record for the highest number of trips leaving Valdez, all of them completed safely, without spillage. In the wintertime, a season of exceptionally rough seas and heavy winds, this is one of the most treacherous runs of all.

"Boy, she was a submarine!" one former bosun told me as he described weathering the Alaskan winter storms, his face beaming like that of a child remembering a particularly terrifying roller coaster ride. "Dove right through the waves!" The other sailors in the mess hall smiled in agreement. One of the cooks leaned out of the galley, and recalled his first trip aboard the ship in 1978. They had rough seas coming down from Alaska. At one point the ship ended up in a trough between two waves, and it rolled so far into the oncoming wave that water came gushing down the stack and extinguished the port boiler; somehow the ship fought her way out. When they made it down to Port Angeles, and the ice and snow that was thickly encrusted over the deck had finally melted, the crew could see that many of the deck fixtures, ladders, and parts of the catwalk had been ripped off in the storm, as if the

ship had been mauled by an angry beast. The cook laughed. In all the years he had been on her since that first harrowing trip, he had never lost faith in her seaworthiness. "She never let me down."

The original crew now finds itself on a brand new, double-hulled diesel ship, one not subject to a kill date like the *Minole*; however, this leaves them with mixed feelings. On the one hand, their jobs have been preserved, at least in the short term. The new ship was bought at the last minute, and so losing their jobs altogether had been a distinct possibility for some time. However, there is a sense that a new ship should mean more than what this one brings.

The *American Progress* was built on a budget; she is expected to last as few as fifteen to twenty years. She was built at Newport News, which, like most other American yards nowadays, usually only builds military vessels; in fact the shipyard had to call builders out of retirement who still knew how to build merchant ships because it had lost some of its former know-how. Sparrow's Point, the once mighty Bethlehem Steel yard at the mouth of Baltimore harbor where the *Minole* was built, is now an almost defunct repair facility, a quiet shadow of its former industriousness. In comparison to the fluid lines and solid construction of the *Minole*, the new vessel is boxy in design, and looks tinny. Much thinner steel was used to build her, and, while one assumes it is seaworthy, it looks insignificant in comparison to the 1 1/8" thick plate on the *Minole*. The captain leaned over the rail to point out the alarmingly large dents in the hull left by the last tug. "I would never want to be aboard THIS ship in one of those storms," he said, frowning with distaste.

The *Minole* looms large and fondly in their memories. Her disadvantages seem only to diminish in retrospect. For example, most operations on the *Minole* were wholly manual. This meant a lot of hands-on effort when it came to loading or unloading cargo; hours of turning valve wheels that

had often stiffened with age and were no more limber for the heavy, Alaskan cold. "Yeah, it was more work," one AB, an able-bodied seaman, told me, "but it was more fun. All that elbow grease made you feel like you were a part of her."

Here was a ship that was built to last; by modern standards she was even overbuilt. She had the same aesthetic as old fifties cars. She felt solid and luxurious, with few hard edges or right angles, inside or out; everything, from the design of the hull and houses to the passageways and cabins, had a slight curve to it. One has the impression that no expense was spared to build her well and beautifully. One of the former engineers told me that when a ship goes into the shipyard every few years for repair, it generally has as many as 300 steel fractures in the hull. He claimed the *Minole* had only had twelve in her whole life.

This perception of diminishing permanence extends to their jobs as well. U.S. merchant shipping has been steadily atrophying since the end of World War II; in the last fifty years the domestic merchant fleet has dwindled from almost 5,000 ships to just a few hundred. The *Exxon Valdez* spill put further pressures on the tanker fleet by increasing the liability of oil companies, and thereby straining their commitment to running ships. Most of them have chosen not to replace their domestic vessels as these are phased out. The American Progress is the sole remaining ship in Mobil's fleet operating under the US flag; the sailors worry that it is only a matter of time before the company pulls out of the domestic fleet altogether.

As such, the new ship is just an anxious stopgap. It replaced the *Minole*, but not what she represented. The *Minole* was a relic of an era of greater certainty and ease. Forty years ago, sailors were sure of their ship and their jobs; both seemed capable of lasting indefinitely. That has worn away in the last decades; everything has become skittish. The sailors' future is vague and hard to predict. All of them acknowledge, tacitly as well as explicitly, that something special passed with the *Minole*. To see her decommissioned was to bid farewell to a whole period in shipping, a more confident time.

"So she was a perfect ship?" I ask the crew.

"Well … almost," the first mate started in. The only major complaint was that she handled sluggishly. She was the largest ship of her day when she was first built, and the crew claims that the yard didn't give her a big enough rudder to match her unprecedented size. On one of the last runs before Mobil sold her, the ship made a coastwise trip that ended in Providence, where she had made her maiden voyage in

1961. When the pilot came aboard in Narragansett Bay, he recognized her, despite the various name changes and paint jobs. To everyone's surprise and delight, he was the pilot from that first run. As he removed and hung up his coat, he walked admiringly around the bridge before taking the wheel, remarking how beautiful she still looked. Then he turned to the first mate and asked, "Does she still steer like a dog?"

≈ ≈ ≈

At the dock in Violet, the *Minole* waits for her last crew. They arrive slowly, a few one day, several the next, until all twenty are there. They come from all across the United States. Some of them know each other from the company's other vessel, the *MV Sea Princess*, or from other U.S. tanker companies. Because this is the first time many of us are sailing together, and on this particular ship, there is far less social cohesion than among the ship's original Mobil crew, who have sailed with each other for years and know each other very well. In one way this also creates a relaxed atmosphere; whatever distance lies between us is also a form of tolerance and acceptance. There are no past attachments to make anyone too territorial, and there are no commitments to the ship past its delivery to the scrapyard. Other than being quite long, and stretching out over the year-end holidays, the trip itself should be relatively easy. Any ongoing maintenance of the ship's long-term functions, which normally takes up so much of a sailor's time under way, will not be done here; the ship should pretty much drive herself there on her own. We will just let her fall apart.

I have joined this ship not as a seaman, but courtesy of Rick Stickle, the shipowner, who has allowed me to document the ship's final days. I came hoping to document the relationship of a crew to their vessel, but I find instead people who seem quite aloof from her. I came to see people let go of a ship, but found that she had already been abandoned by those to whom she once belonged. To this last crew she is just another old ship, one with a history that they can sense, but which they do not know or perhaps care about. Their attachments are to other ships. This job is just a detail, a pause as their lives go on elsewhere.

The ship feels us walking her decks and corridors, and knows we are not her crew. It is not merely what we are doing but how we go about it. We respect her, but we do not know her, and we handle her without familiarity. She is for us a body, not a person. We are merely her undertakers.

≈ ≈ ≈

The demurrage at the grain dock lasts almost two weeks. The facility is old, and the ship not easy to load. Clouds of dust billow across the decks from the three loading chutes. Standing too close to any of them, one feels engulfed, as if in a sandstorm. The longshoremen are fully covered, wearing goggles and towels across their faces as makeshift masks.

Slowly final preparations are made for the voyage. We will not stop along the way, and so must take on everything for the next two months now. Fuel, medicines, and stores are loaded: hundreds of pounds each of meat, rice, pasta, fish, flour, butter, milk, canned goods, pies, ice cream, fresh vegetables and fruit. On the final day of loading, the longshoremen assemble their gear, and give us their adieu. They are impressed by the ship. It is the oldest they have ever seen, and one of the few U.S. flag vessels to have come into this dock in recent memory; it is the only one they have ever loaded for a final voyage. They have been our guests in the galley since the first day here and have become

She had the same aesthetic as old fifties cars. She felt solid and luxurious, with few hard edges or right angles, inside or out; everything, from the design of the hull and houses to the passageways and cabins, had a slight curve to it. One has the impression that no expense was spared to build her well and beautifully.

our friends; we find their warm garrulousness and Louisiana drawl very entertaining. They have grown to feel at home aboard her. On that last afternoon of work, some of them pause for a last look at this beautiful old ship, giving her their own affectionate goodbye.

≈ ≈ ≈

People aboard seem aloof, as if elsewhere, either on another ship they know better, or at home with their loved ones. Only with a few days to go have they begun to acknowledge that they are in fact here, not where they might rather be. Easy as this voyage may be, probably a tangential, unessential detail in the overall scheme of their lives, it is still in itself a significant occurrence. It begins to feel so much bigger than us; we belong to it more than it does to us.

Everyone has spent an inordinate amount of time in these first weeks debating the details of the trip: where we will end up, how long it will take to get there, whether we might in fact stop on the way, and where. Mealtimes are consumed with impassioned predictions and confident refutations. This speculation feels external, hypothetical, as if we were trying to resist the idea of the trip altogether. Now, as the departure date approaches, the debate has entirely ceased, and there is almost no mention of the voyage. The mood sinks. We run final errands and make the last phone calls to our families and friends; only then do we realize just how far away we are withdrawing from everywhere, everything, everybody we know.

On the evening of departure, we sign the ship's articles, which commit us to the trip; only then do we begin at all to relish the thought of the voyage. Going is now more imminent than leaving; the frustration of being on a ship that doesn't move dissipates. We begin to indulge in some sense

of adventure. As the ship makes steam, several of us stand on the foredeck watching the traffic that moves across the I-10 Bridge. They are all going home. For most of them this must be a day like any other, comfortable for being ordinary. For us, who feel invisible to them, it is anything but.

That rainy night of November 18 we cast off, stow our lines, and begin making our way down the Mississippi. We leave land, and it leaves us.

≈ ≈ ≈

Out in the Gulf of Mexico, land vanishes quickly from sight to the north behind us as we steam southwards. The sun and wind are warm, the ocean wide, beautiful and calm, the color of sapphire. Its hue is deep, yet vibrant. I have never seen anything like it. I feel as if I have entered a secret world, one known only to seamen; when I say this, all the sailors tell me serenely, "This is what we come out here for."

It is splendid and also terrifying. Loaded down to our marks, the water rushes by swiftly and indifferently a mere fifteen feet below the main deck. Standing alone, leaning against the rail, it is impossible not to look down at the rich, deep-blue water, and wonder how easy it would be to fall in, to be lost in this vast space. Even in the calmest of seas, the ocean remains a threat that forms a constant part of one's thoughts.

At the end of the day the ship hurtles into the dark like an arrow shot into the void. There is no horizon on this moonless night, only stars in the dome of the sky under which we pass.

The sound of the reduction gear in the steam turbine is tremendous. One can feel it everywhere back aft. No one in the galley seems to notice; they are all used to it, but I find it impossible to ignore. It isn't so much noisy as full. A diesel ship's vibration is small and fast, almost neurotic in its percussiveness. This is big and smooth, circular and churning.

The boilers roar steadily. The whole steam plant feels matriarchal, almost mythical. Standing at four stories tall, it feels more like a building than a machine, like a blast furnace in a steel mill. It powers and heats the whole ship, a large and ferocious heart.

The engineers' quarters are directly over the engine room, which to my surprise is preferable to them. This way they can hear everything; unpredicted new sounds or vibrations - or the absence of other usual ones - wake them up immediately, telling them that something is not working properly and needs their attention. It is a very sophisticated acoustic environment. To a layman it may seem only an indistinct, almost deafening level of noise, but to them it is a well-memorized symphony of pumps, generators, condensers and pipes.

I had always imagined that the inside of the body was somehow silent, as if it were underwater. As I stand at various points inside the ship, I now think that it could not be that way. One would have to hear all the functions, this vigorous roar of an organism at work.

≈ ≈ ≈

Excess grain spilled by the loading chutes covers the decks here and there; it has rotted and even sprouted grass. In the first days the deck watch is called out on overtime to shovel it off. After that, people settle into a routine confined to standing their usual watches, four hours on, and eight off. Only the cook experiences little reprieve to his usual schedule. Normally there is a world of maintenance to be done: chipping and painting to protect the vessel from the constant onslaught of salt corrosion and rust, the monitoring and repair of the ship's many functions. There is no point in fixing anything here, because it only needs to hold together this one last time.

In one way this makes for an easy trip. With some exceptions, the work is kept to a predictable minimum of eight hours a day. There is more time to relax and socialize, to tell stories and watch movies. On the other hand this makes the trip quite difficult. Overtime is lucrative and makes time go by more swiftly; it helps justify the separation

from a familiar world. If one is to isolate oneself and place one's life at risk, most sailors reason, it might as well be for good money.

But it is not only the lesser financial compensation which is aggravating. Like all people who take pride in their work, it is frustrating for sailors not to exercise their craft. A sailor's work is also a form of instinct, because it guarantees his survival. A ship must be maintained, not simply to keep it running, but to keep it afloat. The ocean will swallow her up if one doesn't. Salt begins to corrode a ship the minute it is launched into the water, and much of the deck work involves fighting this relentless process. The ship constitutes the only barrier between ourselves and an environment which will not support or nurture us. So much work and knowledge goes into building a vessel and then to keeping it running; a ship's life is a history of the often extraordinary efforts of engineering and navigation many sailors have made to get a job done and survive the wrath and force of the ocean. To end that tradition and disengage from this process thus feels not only decadent, but also contrary to a sailor's nature.

Ultimately all that extra time turns into an opportunity to sit and think, to wonder how our families and friends are doing as we pass through the major year-end holidays, to remember how far away we are from them and our lives ashore. Our solitude feels as deep as the surrounding ocean itself.

We watch the decks rust. I tell Papa John, at 71 the oldest sailor aboard, that it's sad to see such a good ship fall apart, to let her go.

"Yeah, the ship sad too," he answered.

"Really?"

"Oh yeah, she cryin', she cryin' all da way …"

We do at best about 13 knots, or 15 mph, and have a total of more than 13,200 nautical miles to traverse. "Imagine being on a bus going nonstop halfway around the world, stuck in second gear," the chief engineer explains to me over the din of the steam plant. He waits a second for me to grasp the image. Then, raising his arms and looking upward into the cavernous, several-storied engine room around us, he smiles acerbically and shouts, "Well, here we are!"

At such a snail's pace, that we will make it at all in forty days seems a miracle. It reminds me of a grade school biology movie that illustrated how the human heart pumps enough blood fill a supertanker in four days.

≈ ≈ ≈

"There's a whole lot of nothing out here," Sparks, the radio officer, tells me languidly as we make our way out into the Atlantic. So far there have been other ships regularly in view, and frequent land sightings. Now there is just a wide and lonely expanse. It is a gray, colorless day. Marauding waves crash into the hull, sending a white sheet of spray over the bow before they move on indifferently, like some passerby vanishing into a crowd, unaware of having bumped into others at all.

The South Atlantic is the loneliest stretch of ocean. Almost all ships going to the Far East take the Suez Canal; we are rounding the Cape of Good Hope instead. For days and days there is nothing on the radar screen, even at several hundred miles of range.

The sea is silence.

One can hear little more than oneself; besides the noise of wind and water, any sound is of the ship. In the morning as I awake, I momentarily imagine that I am in my childhood home in Maine,

that I hear the sounds of other living things: birds, insects, trees, all declaring their acoustic life to me. Instead I come to realize that it is only the particular whine of air escaping from a valve, or a coffee mug rattling on my shelves as the ship rolls strongly. Just as one's visual perceptions are reduced to a subtle, limited set of factors, one also hears fewer things out at sea. There are no percussive or sharp noises, only the sibilance of waves softly caressing the hull, and the ceaseless wind, which is a breath without vibration, the sound of infinity.

The sea in its sameness is oblivion. One day is similar to the next. Like waves they are each different as they occur, and then the same after they have gone past. This gives one a sense not as much of monotony, but a hypnotic repetition in the landscape and one's daily rhythms. Whereas boredom is a confinement within time, here there is a meditative peace, something on the verge of an open-eyed sleep which leads one out of time. Events are remembered, but not their sequence or context, and soon we wonder whether we are moving through space and time, or standing still. Even with telex and satellite phones, we cannot tell if we are somewhere or nowhere. All memories blend into one landscape of sea and sky, disappearing from one's mind like the wake of our ship in the midst of this vast and forgetful ocean.

The ocean seeps into us. Rolling like the waves, one's mood changes unexplainably from one day to the next, sliding from levity to sadness, from adventurousness to homesickness, from sensations of freedom to ones of utter frustration. One day I feel active photographically, and on the next I find that it's impossible for me to get anything done, as if I were sleepwalking. Some days I barely feel able to speak to others. I can feel the ocean entering my movements, influencing my body, whether I am standing or even sleeping. It even affects the rhythm of my conversations, which follows the ship as it rolls.

December 4, 1997, 12:00 p.m.
Greenwich Mean Time
Latitude: 22° 48' S
Longitude: 7° 42' W
Heading: 125'
Speed: 1 knots
Beaufort Force 1,
sea almost like a mirror
Air Temperature: 79°
Water Temperature: 70°
Wind: 1-2 knots

It is a sunny and resplendent afternoon. On such a calm day it feels as if one were on a flat and elevated plane on top of the world: closer to the sky, barely underneath the clouds that seem to pass just a few hundred yards overhead. Were this not the loneliest place on earth at this moment, I would call it the most beautiful. Off the port beam, at a distance of only a mile or two, something astonishing catches our eye. A whale spouts, then springs forth, letting its heavy body crash against the water. It alone punctures the otherwise still and empty surface. At play all by itself in this wonderful immensity, it easily defies its own and our solitude, exalting in a freedom that we imagine, but cannot feel or attain.

≈ ≈ ≈

One of my favorite places on the ship is the aft lower deck, where the crew quarters are located. There are almost twenty empty cabins that once housed the many crew members taken off the ship's rosters years ago: bakers, mess hall waiters, bedroom stewards, a butler, and even an ordinary seaman whose job consisted entirely of shining all the brass aboard. Their doors are lashed open, and light streams into the corridor from the cabins' portholes. The space is airy, even serene. Thirty years ago this would have been a hive of activity. I imagine my college dorm afloat at sea.

The ship was delivered thoroughly clean. Other than a few pieces of porn tacked to the inside of closet doors and some old company shirts that were left lying around, the cabins are pristine, without a trace of their prior inhabitants. Each holds nothing but a bare mattress and bed frame, a desk, and a chair. They offer no clues, except for their very emptiness.

≈ ≈ ≈

It is not easy getting to know many of the crew. Because of the round-the-clock watches, everyone is on a different schedule, and so one simply doesn't run into many people in the course of the day. It seems as if one is more likely to hear a door slam shut than to see anyone. There are only twenty-one of us, and the ship, originally built to accommodate almost fifty, absorbs us easily. A few people are always to be found on the bridge, in the engine room, or in the galley, but that is only for work. It is hard to understand when, where or even whether people congregate socially. Mealtimes are perhaps the only time people linger a little, but even here many people are businesslike and keep to themselves. People cluster in groups of one, two or three, but not more. We are too few, and the trip too long.

Almost everyone imprisons themselves in their cabins when they are not at work. The most sociable time outside work and mealtimes seems to be watching a movie on the VCR in one of the common rooms, but it doesn't feel that way. It makes time go by in a passive, narcotized way, which is why I often avoid it, although at the same time I recognize this to be part of the attraction. People don't hang out in each other's cabins to shoot the breeze or play cards, for example, as sailors told me

they often used to in the past. We all navigate our own melancholy boredoms and solitudes.

With persistence and patience, I slowly push my way into people's lives. I make portraits and interview the crew. I am determined to find out the answers to "Why Do People Love Going To Sea" and other such dramatic questions. They give responses that are vague and more mundane than the philosophical and poetic ones I hope to elicit; no monumental archetype emerges from the details. These are people who describe their lives and work, including this job, simply, even plainly. There seem to be no special reasons for this trip or many others; remarkable as it should be, it is instead quite ordinary for many of them.

It eventually occurs to me that it is precisely the ordinariness and the regularity of routine that many of them find compelling. Life is simple on the ship, and leaves one's mind clear. Everything is provided, and there are no distractions. We are sheltered from many of the unpredictabilities of life; it is reduced here to a constant, repetitious rhythm, and apparently, the plainer the better. I find this attachment to the regularity of one's daily rhythms fascinating, and make notes of people's habits: where they sit in the galley, what they joke and talk about, what they eat, where they go to smoke a cigarette. For many it is always the same. And if I ever break my routine, by skipping breakfast for example, others comment immediately. We identify each other for what we do the same every day: Jerry walking into the galley half inspired, half paranoid, strutting like a thug, except he's 5' 2" and skinny; Steve making sarcastic comments and imitating Beavis; Sal asking an offbeat question; Bob counting the days till our arrival, "18 days and a wake-up!" It all becomes ritual and familiar.

Rumors provide darker hints of who someone might really be. Did one of the ABs do time for killing his brother? Is Sparks an ex-CIA operative? They don't tell me, and I don't know how to ask. I can't seem to find my way to them. Is it my tape recorder, my forcing the dialogue by scheduling the interview? My association with the shipowner for merely being his guest aboard? I am with them, but not one of them. I remain the passenger and the observer. There's no dirt on me, and as a result I sense that I am somehow not to be trusted.

"All sailors are out here to get away from women, debts and the law, and that's no joke. Don't put that in your book, but it's true."
"Is it true for you?"
He chuckles and coughs on his cigarette smoke. "Maybe."
"Will you tell me which one it is for you?"

Without the slightest hint of defensiveness, he replies, "Maybe." He puts out his cigarette and drifts back to his work.

≈ ≈ ≈

Out on the fantail in the warm evening breeze, people tell stories about times on other ships, crews they know, and ports they've visited. Certain people from other ships get talked about so much, it feels as if they are aboard with us, and part of the crew. One such seaman is always the subject of more laughs than the other.

"You remember that time in Savannah he came walkin' back to the ship?" They can barely breathe, they are already laughing so hard.

"She took him back to her place, he doin' her, and she was screamin' it out to him, "Take it, take it all, it's ALL yo's!!" He thought, "Yeah, I da big man now, but when he got outta theh, an' he reach inna his pocket ..." Noah is crying from laughter, his face cramped and immobile. He pauses to regain his composure, and stutters back to the story his howling audience is waiting for him to resume. "An' he ... he open his wallet ... all the money ... GONE!!!! She have some otha John under the bed goin' through his clothes! So he think HE da big man, but she callin' it out to the otha guy the whole time! TAKE it, take it ALL, it's ALL yo's!"

≈ ≈ ≈

In the middle of this hypnotic expanse, people often become odd. Many exhibit behavior extending to the bizarre, or at least appear to be privately nursing uncomfortable thoughts. I for one am afraid that my appendix is giving way. I am convinced I feel an unusual tinge in that part of my abdomen, and I'm almost sure it hurts. I often stare at the radar, calculate the hundreds of miles from shore, and anxiously wonder how far out of range the ship is from a medical helicopter. The officers with whom I play darts every night before dinner would perform the operation. I am happy when they outplay me; somehow this means that their precision with the darts will extend to a knife.

One of the engineers believes he is going to be poisoned. He mutters something about this as he sits down with his dinner across from me, seemingly unaware of my or anyone else's presence. He timorously examines the food with the delicate precision of a bomb defuser, poking it lightly, carefully turning it over, now examining it from an angle, presumably to better judge the glisten of the fat on the chicken. Eventually he commits to eating. The first bites and chews are still slow, as if he were sifting for glass shards. His eyes dart around nervously, but he looks at no one.

"Do you have cigarettes?" The tone is urgent, of someone asking for medicine to help a sick friend.

"You know I don't smoke."

He looks disappointed, both because I have none to offer, and because I don't appear to have started smoking since the last time he asked me, two days ago. Without saying anything else he turns away and, clearly still looking, wanders down the empty hallway. He tries bumming them from everyone, but doesn't get more than a few; everyone is worried about running out, and they are, after all, for sale in the slop chest. Once he has exhausted everyone's goodwill, and after still refusing to buy any, he begins compulsively eating canned fish like the mother in *The Tin Drum*. Hunkered down low to the edge of the table, day after day he consumes tin after tin of squid, mackerel and sardines.

That rainy night of November 18
we cast off, stow our lines,
and begin making our way down
the Mississippi. We leave land,
and it leaves us.

As we come to the latitude of the top of the Straits of Malacca, there is suddenly a world of traffic on the radar. We are crossing one of the busiest shipping lanes in the world. Ships take this route from East Asia through Singapore to the Middle East, and through Suez to Europe and eventually on to the Eastern U.S. I stand on the bridge looking in amazement at the beautiful outlines of so many ships in view. It feels like stumbling out of the solitary forest onto a busy road.

Sparks invites me to the radio room to hear the vibrant chatter of Morse code, a rarity nowadays. The *Minole* still has its telegraph system, but it had been disabled for a few years until he got it up and running again. Thoroughly outfitted with satellite phones, shortwave radios and telex, the telegraph is hardly necessary in this radio room; Sparks grew up on it, though, and sees it as the simplest and most fail-safe system of all. Many of the small vessels we are seeing run only between ports in the Eastern Indian Ocean and are not fitted with much equipment, relying principally on Morse code. Sparks listens to the insect-like clicking of code with the animation and nostalgia of someone who hears a piece of music for the first time after many years. He doesn't comment on what is being said, but on its diction and accent. "This guy taps beautifully, real smooth and relaxed … That must be a young guy; his tap is kind of nervous and fast – doesn't have the feel of it quite yet. Takes a while, you know; it's like a musical instrument, really."

He begins to explain the subtleties for me on the telegraph, but he catches himself just as he is taking off. He stops and looks away. His private smile seems to say that what he knows doesn't matter much anymore, even if he has an enthusiastic audience in me. It's not just that most ships don't use Morse code nowadays, but that they no longer carry radio officers at all. They use GMDSS instead, a satellite system by which the deck officer on watch can transmit and receive information and emergency calls. It's relatively simple to use, but also full of bugs; it often sends out false alarms, and most radio officers say that it makes people less responsive to real distress signals. Imperfect as it is, though, it has replaced yet another job on the ship.

This is Sparks' last trip.

≈ ≈ ≈

"How slow had been the days of passage and how soon they were over."
Joseph Conrad

≈ ≈ ≈

Within a few days of our arrival into Chittagong, telexes pour in from the Bangladesh agent, the Ancient Steamship Company. As the details of future events become known to us, the clock starts ticking again in forward motion instead of in cyclical time. Within two days of dropping anchor, some sailors begin to smell land and the ocean changes color from its usual rich blue to an emerald, then jade, eventually to murky brown. We begin to see small fishing craft. Underway one felt unsure of how long one had been gone from land, and now that we are pulling into port, we can't remember what it felt like to be out at sea. I can no longer imagine water splashing over the decks or feel the magnificence of the expanse. The door to that secret, almost wordless world has been closed behind us. Time and space on the open ocean are instantly a distant memory, compressed into a single moment, a state of being. Forty days – how was it divided into weeks, days and hours? How odd to remember it so little, when it felt so huge to be in the middle of it. Time seems as fluid as the water that surrounds us. In its sameness the sea has erased even a memory of itself.

The ship is too big to enter the port of Chittagong, which sits on a tidal river, and so we must remain at anchorage and transfer grain onto smaller ships, which will then carry the cargo to dry land. The longshoremen will live aboard our ship for the entire duration of the unloading.

As we drop anchor on the afternoon of December 27, a ship comes into view to the north, emerging gracefully from a Turner-like haze. It sails past us to the west, spins around to the south, and comes alongside to tie up on our port side. Lined up along her starboard side are several hundred men closely watching the ship's approach, as if it were the start of a race. Lines are not yet cast when they begin shouting and springing aboard our ship like friendly pirates, each clutching a bag of belongings. Balanced precariously with one foot on the deck rail of their ship and the other on the bridge wing of ours, seventy feet above the racing current channeling viciously between the two ships, people clamor to their compatriots as they ferry people's belongings aboard. Others rush to claim various open deck spaces for themselves. When we are tied fast, pilot ladders unfurl, and more people board, followed by cargo baskets of live chickens and goats, rice and firewood, and then, finally, the large unloading machinery.

A myriad of eager, smiling faces greets us after so many days of rarified solitude; it feels like walking in on a giant surprise party. We utter the Muslim greeting to them: "Assalaam Aleikum!" Any apprehension of our offending by mispronouncing or misstating is instantly quelled by the resounding shout which returns to us: "Wahalaikum assalaam!" People run up to us, and, after shaking our hands, press theirs to their heart. Some speak a few words of English and express their gratitude at our newfound friendship; many others begin asking for soap or an extra blanket.

They are very expressive and friendly, and they enliven but also bewilder us. We do not even understand their emotions through their facial expressions; at first I only recognize a smile or a straight face. Their body smells, thick with curry spices, are different from anything we have ever encountered. They stand close to us without any regard for the personal space that Westerners are accustomed to, grinning the whole time; it feels menacing at first. *Paan*, the betel nut and tobacco mixture they chew, stains their teeth and gums a dark orange; at first we think they all have trench mouth. It is hard to discern their motives when they approach us with such seeming urgency. Fear often gets the better of us, and we feel overwhelmed; curious as we are about them, we retreat to the safety of the ship's

quarters where, albeit besieged, we maintain our cultural sovereignty.

≈ ≈ ≈

I never remembered a dream in our forty days under way. Only when we dropped anchor that first night and stopped moving, did I start to dream again. Was the whole trip, so long but then over in a moment, one long night of many dreams?

≈ ≈ ≈

People waste no time in setting up the grain evacuators, a sort of truck engine vacuum cleaner that will transfer the grain out off our holds through long hoses over onto the lightering vessel. Foremen blow whistles, workers yell to each other, wrenches clank as machines are assembled. In a few hours they fire them up. The din is immense and the cloud of dust which engulfs the ship worse than during the loading process. We must all sleep with earplugs. Meanwhile, in the open areas of the ship's decks, people have pitched tents, and started cooking fires. Livestock runs freely, as elsewhere some offer their evening prayer. At the entrance to the aft house, a whole bazaar has sprung up; stepping over some who are sleeping, one receives endless urgent solicitations from others, be they barbers or cobra skin salesmen, to buy or trade. Many ask for additional work; they are not currently employed, but, eager for work, have hitched a ride with the longshoremen.

We have been transformed in no time into a floating Bengali village. This new world washes over us just as the silence of the ocean had. In the sanctity of our inner space, we maintain the same routine, language, and diet for our continuity, but outside quickly succumb to the disorientation of another world which has overwhelmed ours. We know they will ultimately come to fully possess this ship, but we are still not ready to surrender it to them.

≈ ≈ ≈

There are voices in the ship, ones most of us do not hear. Work has remained stalled throughout the unloading on one of the port wing tanks. Several times I've noticed a crowd gathered around the tank lid, and in their midst a foreman yelling threateningly at the longshoremen who surround him. No one seems to want to go in. Some he tries to force into the tank, grabbing them by the arm and neck, and pushing them towards the ladder; the workers brace their arms against the ladder and resist his angry shoves. Most ultimately refuse, and wrest free. It is only with the most vehement of browbeatings that some are eventually humiliated into going in to finish the job. Later I ask one of the other supervisors who speaks English why the workers needed to be coerced so to perform work they seemed otherwise perfectly willing to do. "They hear the voices of dead men calling to them, and it makes them afraid."

Noting my surprise, he sets about trying to explain this phenomenon better by telling me the story of another American tanker which arrived a few years before. Bad luck appears to have followed it into port. Halfway across the Pacific it twisted and broke its propeller shaft, and from then on had to be towed; a voyage predicted to last only a month in the end took twice as long. The unloading was delayed by harsh, unseasonable rainstorms and then the accidental death of two longshoremen. When the vessel beached, the shipbreaking workers flatly refused to go aboard, claiming that the ship's holds were haunted. It was finally refloated and towed around the subcontinent to the yards

At the end of the day the ship hurtles into the dark like an arrow shot into the void. There is no horizon on this moonless night, only stars in the dome of the sky under which we pass.

in Alang, where it was then beached again and finally broken.

The next morning, as I prepare to begin my day of photographing, I receive a knock on my door. It is Mr. Aminul, the agent responsible for the discharge, who is staying with his nephew across the hall from me in the lazaret, the ship's hospital. In a lowered tone that seems to request privacy, he asks to come in and have a word with me. Would it be possible to find other accommodations on the ship for them? As far as I know, I tell him, all the ship's cabins are taken, either by the crew or officials monitoring the unloading; regrettably the lazaret was deemed to be the most comfortable, which is why it was offered to him, the chief in charge. When I ask why they would like to change cabins, he tells me only that they have had several sleepless nights; in fact he looks poorly rested, but he seems hesitant to explain. Was it mere jet lag? He shook his head. No, they make this trip from the U.S., where they are based, many times a year; it wasn't that. The noise of the machinery? No, now with a smile almost wistful, as if to say, "If only …" It wasn't the noise either; they were perfectly used to that as well.

In my curiosity and eagerness to help him, I quickly exhaust the list of usual suspects. I suddenly realize from my louder tone and his sheepishness that I have unwittingly forced a sensitive issue; so I back off, leaving us in a silence which quickly becomes uncomfortable. He looks at me almost apologetically. For a few moments his mouth is open but speechless, as if his English, fluent and very idiomatic from many years of living in the U.S., were suddenly failing him. He confesses, "Someone is dying … He is crying out to us. We hear him when we are awake, and we hear him in our dreams too."

A few years after, other sailors from the ship's earlier years would tell me about people who had died aboard. An accident in a shipyard in Cadiz in 1994 claimed the lives of two workers below deck.

When I offered the number of the tank where I had seen workers refuse to enter, they were confident it was the same one. A captain recounted to me how he lost a mate who fell off a ladder to the bottom of a tank, and later died in the lazaret. The incident had shaken him to the core. When I relayed to him the story of the longshoremen and Mr. Aminul, he took it without any apparent surprise, and instead appeared to interpret it as a confirmation of what he had described to me as his worst experience at sea. What was fantastical to me was all too real to him. His expression clouded as it all seemed to come rushing back to him.

≈ ≈ ≈

Amused and fascinated as the crew is by the noisy carnival of events, most people seem more eager than ever to get off and get home. In this hectic and close-quartered cultural confrontation, the familiar and comforting quiet and spaciousness of the sea are long gone. Amidst this chaos there also exists a level of corruption on the part of many authorities which leaves us paranoid. Initial requests of customary baksheesh, be it a carton of cigarettes or sodas, which we gladly fulfill, turn into unrelenting demands for electronic equipment and large sums of money. That first night, the customs official assigned to the vessel pulled out a gun in the captain's office and, in a threat thinly veiled as a reassurance, stated to the captain that, not to worry, "everyone" would listen to him.

We put faith in many who then disappoint us, and are not cautious or cynical enough. We recognize that many of them are good hearted, but have little idea of how their social situation encourages this type of corruption. Eventually we recognize how ingenuous and vulnerable we seem to them, and make a better stand of it. Nevertheless, the situation is so trying for many of the crew that most of

them turn their backs on this experience before it is over, and tensely count the hours until departure.

After eight days the unloading finishes and the longshoremen leave; after a night of extended goodbyes as exuberant as their initial greetings, the ship is once again quiet. Most of the crew leaves the following day; by contrast these goodbyes are perfunctory, even disappointing. Perhaps the tension of having to make their way through Bangladesh in order to fly back to the U.S., at the hands of authorities who seem both corrupt and incompetent, has gotten the better of them.

≈ ≈ ≈

Eight of us remain with the ship until the next moon tide, when she will be beached north of the city. We receive members of the shipbreaker's office who have come to inspect the ship before finalizing the purchase. They spend several hours scrutinizing the ship very carefully from top to bottom. They walk with small magnets that they place on many of the surfaces. They are checking for nonferrous metals, such as brass, the varying presence of which greatly affects their profits; it is their spermaceti.

They behave with far more self-restraint than almost everyone else we have dealt with, but no less warmth. When the captain introduces me to the breaker, and explains to him that I have come to photograph the ship's last life and death, he extends his full welcome to me, and says he will help me in any way.

A thick fog envelops the ship for much of that last week. The situation improves – and also worsens. We have ample reassurances from the company and the shipbreaker that the situation is under control, yet the demands for extortion from the various local officials continue and increase. The crew faxes back to the ship via satellite that the customs officer and the agent demanded money from them, refused to take them to a hotel, and instead kept them confined in an office for ten hours before taking them to the airport. That very night pirates board us and steal 3,000 feet of aft mooring line. Even after we hear on the radio that five other ships have been hit, the Bangladesh Navy does not respond. The next day there is an emergency call from a vessel which found itself adrift in the Karnaphuli River and needs tugs because it cannot fire up its steam plant fast enough to move on its own. The last the captain knew, he was tied up at the dock, but apparently pirates had stolen his mooring lines as well.

In our paranoia we imagine collusion between everyone against us: government officials, shipping agents, even the pirates. The skeleton crew makes rounds on the decks, carrying pieces of pipe. I am especially afraid because I have so much equipment and film on my person, something that the customs official "complimented" me on. So much is at stake for me. I had never imagined that I would be able to organize this trip, and I have counted my lucky stars for having made it this far. The thought of being cleaned out, and being forced to leave at what feels like the beginning of yet another adventure is devastating to me.

≈ ≈ ≈

I've been lobbying Hanif, the agent, to get me a visa. I'd given him my passport a week before, and sent him various telexes to remind him, none of which he has answered. He returns the day before the beaching.

"Everything taken care of!!" he declares, handing me my passport without even looking at me as he walks briskly off the bridge. He is carrying a very large, empty bag.

I leaf through my passport and find no added stamps.

"Haroun?"

"Yes?" he answers distractedly, already a flight of stairs below me.

"Where's my visa?" I ask as I begin to follow him.

"I already tell you, all taken care of!" he shouts up to the landing, not sounding very interested in the matter anymore; he is still walking away from me.

I catch up with him in one of the empty officer's cabins as he is stuffing a blanket into the bag. I find this amusing and, to spite him, photograph him.

"No!" he screams, offended and horrified, and drops the bag. He stands there motionless for several moments. I instantly feel remorse for upsetting him, and am about to apologize for my gesture of poor taste when he steps forward.

"I am poor man!" I now feel even worse for victimizing him. Grabbing the skin on his forearm to show it to me, he exclaims in full melodrama, "Look at my skin! It is dark, but underneath the blood is same color as yours! Please! Don't show this picture to the shipbreaker! I lose my job!" He clasps his hands imploringly. His face is one big, sad frown of worry.

I let a few seconds go by as I savor my unexpected, newfound leverage, looking at him calmly as he continues to stand anxiously in front of me. The blood rushes to my head.

"Are you going to get me a visa?!"

"Yes!" he cries back, shaking his clasped hands back and forth.

"Today?!"

"Yeeessss!!!"

At the same time upstairs I hear someone talking in a low, steady voice which at first I do not recognize as the captain's, which is usually chipper, and often laughing. He is reprimanding the customs agent for having mistreated the crew, and threatening him with a formidable list of reprisals. To my surprise the official with the demeanor of a Mafioso is apologizing profusely. The situation seems to have reversed, and now everyone appears at our mercy. Among ourselves that last night we laugh incredulously that it took such a small push back to contain the situation.

All assurances are given that there will be no more harassment, but we give them no reassurances of our trust in return.

I ask everyone whether they would miss the ship. "Miss all this? No way! We're outta here!" the captain responds unhesitatingly. The ship no longer shielded us from our vicissitudes, and so, it has come to feel like a prison.

I recognize that I confuse the delivery of the cargo with that of the ship itself, two distinct obligations. The crew sees the former as their primary responsibility, while I view the latter as the more significant of the two. They take great pride and satisfaction in fulfilling their mission; it is, after all, no mean feat to move 43,000 tons of food halfway around the world. In an era where many of us work by moving pieces of information and other abstractions, it is often overlooked that people must still physically move the raw materials which make our lives possible. Leaving the ship is instead a mere technicality, like handing someone the keys; for them the real job is finished, and it's time to go home.

Whereas the crew all seem happy and eager to return to their lives ashore, I wonder whether I still have one. I left almost everything behind. I remember having stayed up the whole night before leaving to pack and take care of many last details. In the quiet of the early morning hours, waiting for the taxi to take me to the airport, I sat exhausted on the couch, savoring my last moments in familiar surroundings. Dim, flat light rendered the space static and timeless, like a photograph. There was little evidence of myself around the house: stuffed into the back of the garage were a few milk crates stuffed with clothes, some folders of negatives and prints, on top of which rested an empty cardboard box on which I had scrawled "Mail." My subletters' possessions now took up more space than that. I felt dizzyingly free, almost like nothing at all; I had become a ghost to my own life. The taxi honked, breaking the gray stillness, and I walked out the door to catch a plane to New Orleans. I am not sure how long ago that is now.

I lay in bed that final night with the ship all around me. She had been my teacher, my protector, my home. After so much time away from everything, it was easy to feel as if nothing else mattered but her. Everybody was abandoning her but me, who somehow could not, and in this way I inherited her; she became my ship.

On January 14, 1998, at 2:20 p.m., the steamship *Minole* beached in the breaking yards of Fahad Steel Industries, just north of Chittagong. She started about eight miles from shore and reached a speed of 15.5 knots; even from afar one could hear her propeller beating rapidly through the water like that of a helicopter moving through the air. She crossed the sand bar and plowed to a standstill in the shallow water of the beaching plain, pushing a long wave of water ahead of her which rumbled up the shore. Like an animal shuddering in the throes of death, she slowly vibrated to a halt in that mud, ceasing a movement that had lasted for 37 years and for millions of miles across the world's oceans. "Please, God, please, let it be over for her," the crew thought to themselves. The engineers shut off her fuel line; she choked and gasped, belching one last, thick cloud of black smoke, and then she died.

$$\approx \approx \approx$$

The remaining crew goes home. I say goodbye to them, but they already seem like they are halfway to somewhere else. Rob is going back to his stripper girlfriend, Hank to his rabbits on his farm in Arkansas, Jim to his wife, Sparks to who knows what. I watch my last link to where I came from drive off in a bus through the dusty streets of downtown Chittagong. From the rear window of the coach the captain smiles, shakes his head in disbelief, and waves one last time, as if to say good luck as much as good bye. The bus rounds a corner and vanishes, and I am left to contemplate a large crowd of significantly deformed beggars who now turn their attention to me. A swirl of sounds presses in: rickshaw bells, the cries of many children playing and people walking, the squawking of infinite crows circling in the sky above, a lilting, overly amplified voice which calls the faithful to prayer,

forceful but imploring. I feel myself plunged into yet another world, and yet another journey.

The shipbreakers Milon, Zakir and Shahin are kind and generous, and the beaching master, Captain Anam Chowdhury, is also very helpful and encouraging. They have granted me full access to the yard, and provided me with a safe and clean place to live. I am to be their "guest of honor." I have hired Hossain, one of the workers who came aboard during the unloading, to be my manager; without him I feel blind. More overwhelmed than ever by my new surroundings, I also have a greater measure of trust and comfort than ever before. Shahin tells me, "You are welcome to our yard one thousand times."

$$\approx \approx \approx$$

I go back to see the ship as the breaking begins. She sits a half-mile out from the edge of shore, her hull fully exposed in the low tide. It is a long trudge across the wide alluvial plain to where she rests, through a thick, knee-high, clay-like mud replete with chunks of steel that jaggedly press against one's feet. The mud seems really septic; whenever I cut myself, my skin stings. The combination pilot ladder and ramp are fully extended to reach the ground; my slimy feet slip on the rungs as one makes the long climb up. I am overweight from too many slices of pie in the galley, and generally out of shape. Weighed down by my camera bag, I make the ascent slowly and with a fair measure of dread, especially as workers climb past me on the outside of the rungs.

When one stands anywhere on a live ship, one has the impression that she might leave of her own accord; all the large grumbling and vibrating of her mechanical functions appear to give her a will of her own, one which doesn't need the prompting of humans to move. But there is no chance of feeling

that now. The ship is dead: inside she is still, cold and dark. The steel of the bulkheads doesn't vibrate with movement. There is only the sound of hammers and wedges hitting steel, cutting torches ripping into the hull, the occasional voice which echoes down a dark passageway. At first I feel anger at the workers, who could never know how much has happened aboard the ship, even in these last few months. In fact, they seem timorous. One approaches Hossain and utters something to him in a soft tone of voice. Hossain tells me that he is embarrassed that he is hurting my ship in front of me.

≈ ≈ ≈

Ships have long been symbols of transcendence. Many peoples through the ages, from the Egyptians to the Vikings and beyond, have buried their dead in boats or with vessels which they believed would transport them into the afterlife. The footprint of the Christian church is modeled symbolically on the proportions of Noah's ark; hence, for example, the "nave" of the church, which comes from navis, the Latin word for "ship." The *Minole* has ferried herself into an afterlife, but it is not one that I initially want to recognize. It seems like hell at first to see her so abandoned to be cannibalized; slowly, though, I begin to witness her own transcendence.

In November 1961 in Baltimore Jane McQuilkin, the ship's sponsor, smashed a bottle of red wine across her hull to launch her; on January 15, 1998 the cutting foreman and an Imam smear the blood of a sacrificed goat in various places of the ship to bless her and the workers, to protect them from harm. She ended her travels here, and now something else begins from her; she undergoes an inversion of value and meaning. To the culture celebrating her arrival, she is a source of materials which they will use to help build their society. Just as she involved many people in her seafaring, now in her breaking she will continue to affect the lives of many others.

From this bridge I once saw a row of a hundred dolphins jumping through a sea as clear as a mirror. The orange red of the rusting decks contrasted strongly with the blue and white of the cumulus filled sky; the foam of broken water hissed and rushed peacefully alongside the ship. It is already long ago. Now there is only gray mud and sky, and in the distance, past the few buildings on the shore, some green jungle, all of it obscured by the smoke of the cutting torches.

I smile at the worker, and thank him. I ask Hossain to tell him not to worry; she is now his ship more than mine.

≈ ≈ ≈

Even though it is still Ramadan, the breaking begins almost immediately. The bank collects about $1,000 a day in loan interest, whether people fast or not.

A team of about thirty "fitters" works throughout the ship, stripping, unbolting, and unfastening everything that is not a solid part of the structure. They have few wrenches, which are hardly of any use, as many of the bolts have been tightened and retightened, and then painted over, for almost forty years. On one of the main cargo distribution valves on deck, I count more than thirty bolts. A fitter splits them with a small hammer and crude wedges. No cutting torch will be used here, as the valve is made of brass and would melt under the heat of the gas flame. He goes through several wedges before he breaks the nut; patiently he stops to reshape the blunted wedges. It will take him hours to do this. He looks as if he has a headache from the vibration and shrill, clanging noise of pounding steel.

Using ordinary blowtorches that burn liquid petroleum gas, "cutters" sever chunks weighing fifty to one hundred tons, methodically cutting through myriad layers of decks and bulkheads. One sees them perched everywhere, precarious as acrobats. When they are ready to fell a piece, the whole chunk remains suspended from the deck by just two one-foot stretches of uncut steel. The cutting foreman begins yelling to clear the decks, above and below; amidst these shouts and some shoves, everyone steps back. He then signals to the two cutters to torch through the final pieces. No one else dares talk as he continues to bark nervous instructions; it is completely

quiet apart from his voice, and the hissing, sometimes crackling and popping sound of the torches. The deck shakes; the steel groans as it twists free, falling slowly and heavily through the air. It lands with a resounding, deep thud! which makes the ground bounce underfoot like a trampoline; the sound of the impact echoes off the neighboring hulls like a cannon shot. Mud sprays for many yards and a rising cloud of dust envelops the area. It settles with a brief pitter-patter of falling steel chips and slag that sounds like a momentary rainstorm. The foreman rushes over to the edge to inspect his crew's work. He cheers approvingly, relieved that the cutting has begun well. *"Jahaz gaue!!"* he tells me. "The ship looks as if crows are eating at her!"

A column of thirty to forty "wire carriers" drag a three-inch-thick steel cable a half mile on their shoulders out to the ship, where they will attach the wire to the felled chunk. The piece will then be pulled into shore by a homemade, truck-engine-powered winch. The cable is heavy, and it sways with a mind of its own, forcing each carrier to veer sideways as much as he moves forward under its considerable weight. The workers trudge barefoot through the deep mud, somehow avoiding cutting their feet. From a distance they appear to stagger like puppets suspended along the cable, which seems to move both them and itself.

≈ ≈ ≈

The yard noisily receives the piece of steel, where a second team of cutters reduces the large chunks to flat pieces ready for transport, most of them weighing a metric ton. They crouch patiently over the steel; the torches cut slowly, so they hardly move. The smoke obscures the workers, and the air is thick with the ferrous smell of burning slag. Cutters wear more protective gear than the others, but it hardly seems sufficient. They

Events are remembered, but not their sequence or context, and soon we wonder whether we are moving through space and time, or standing still. Even with telex and satellite phones, we cannot tell if we are somewhere or nowhere. All memories blend into one landscape of sea and sky, disappearing from one's mind like the wake of our ship in the midst of this vast and forgetful ocean.

wear worksuits, boots, and gloves. No one has a hard hat. Some of them wear protective eyewear, but most do not. Some clutch a rag or kerchief to their mouths in place of nonexistent masks. The exposed stretches of their forearms are pocked with many small burn marks.

"Loaders" come to carry the cut pieces up the hill to the shipping area. They are the youngest, strongest, hardest working, and most exuberant of all. Goaded on by a foreman who leads their work chant, about fifteen to eighteen of them crouch around a slab of steel like football players in the huddle; they grab its jagged edges with a small corner of felt.

"Are you strong enough?" the leader sings, and the group responds in chorus, "Yes we are!"

"I'm not so sure!"

"Yes we are!"

"Then show me!"

"Eiare eiare eia!!" comes the final response. With a terrific shout they hoist the gigantic slab onto their shoulders, tucking the felt underneath to keep the steel from cutting into their skin. They walk in unison, swaying gracefully in perfect rhythm under the terrible weight. The foreman sings short verses to them, sometimes obscene and often nonsensical. The loaders answer back with each breath, "Eia! … Eia! … Eia!" They walk in sandals, and more often barefoot over the rough ground to the colorfully painted yellow and blue trucks that wait to fill their orders. There they load the edge of the plate onto the back of the truck and, with a last resounding cry, shove it onto the truck's bed. Often they run back without hesitation to get the next piece of plate, cheering victoriously like crazed sports fans charging the field at the end of a game.

In the meantime other workers unload the ship's many materials. "Oilmen" drain the remaining fuel. Bunker is the lowest grade of refined product; it is almost as thick as crude oil, and needs to be heated slightly to move it from tanks to the steam plant. The oilmen spend a lot of time waiting for the thick pitch to drip down from the tanks into 55-gallon drums, which they then float ashore on the incoming tide. Workers carry many individual items from the ship, be they beds, lifebuoys, plates or blankets.

Occasionally beggar women come around the yards, poking through the mud to look for gussets of metal; at the end of the day they pool their few kilos together and sell them, maybe only for enough money for each of them to buy a kilo of rice and some vegetables. Despite the fact that they collect material that is of no value to the breakers, security guards are quick to shoo the women away, sometimes throwing rocks to drive them off.

≈ ≈ ≈

The ship will be dismantled in this way over a period of several months. There will be no cranes or derricks, only the backs and arms of several hundred workers who will take her apart piece by piece, day after day.

They are from all parts of the country, mostly from extremely poor agrarian areas to the north. The farming which had sustained them for centuries no longer does, and they have found themselves indebted and starving. Many are landless. As limited as the economic opportunities are in the wealthier urban areas of the country, in these regions there are even fewer, especially for those who are unskilled and often illiterate. So they have come here in the hope of earning a decent wage. In fact it pays twice, even three times more than other kinds of comparable labor. The work is readily available and does not require prior experience, a reference or a bribe.

Many have stories of disenfranchisement. Mr. Selim, the head cutter, is an ex-state employee who was no longer able to support his family on

his government salary, and was unwilling to engage in the bribery and extortion that many public officials do to survive. Mufad Jahal is a loading foreman from the northern district of Bogra. Until fifteen years ago he was a wealthy farmer in a village situated along the Jamuna, the name given to the Brahmaputra when it enters Bangladesh from India and merges with the Tista. For eighteen months he watched helplessly as the mighty, swollen river changed course, eroding, then swallowing his twenty acres; he was left with nothing. He contemplated staying on to claim newly emerged ground elsewhere, but contention was strong, even violent among the many farmers who suffered the same fate. He moved his wife and two children to his wife's village, where they owned no land, and then he came to the yards to look for work. Five years ago the family needed more money, and so he took his fourteen-year-old son Ronju Ahmed out of school, and brought him to work in the yards as well. If he had had the choice, he tells me, he would have left his son in school. Now he has resigned himself to their situation somewhat, and tries to make the best of it. Ronju stands a good chance of becoming a loading foreman himself, and earning as much as his father does.

They save money to bring home to their families on half-yearly visits. It is hard to know if it enables them to change their overall situation, to create prosperity, or whether they must use it merely to relieve the immediate impact of their poverty: lack of food and medicine, debt, the cost of their daughters' weddings.

Their life is backbreaking. They work five or six days a week, twelve hours a day, and the pace is relentless; some of the foremen are quick to push and shove when someone slows down or gets distracted. The heat is tremendous. By late February it is already ninety degrees Fahrenheit and stiflingly humid.

The breaker provides their room and board. Sometimes these are long row houses, well made with raised concrete floors; other times they are shanties with ground-level floors of dirt that turn into mud in the rainy season. They sleep bunched together on mats unfurled over the floors, or over unused scrap pieces of steel that they prop up above the level of the ground. There is no plumbing, so they must use outhouses on stilts at the water's edge. Because the tide is weak, often much of the waste merely redistributes itself along the beach.

Three times a day they eat huge bowlfuls of steamed rice with a thin dal, a sort of watery pea soup; this is the staple food in Bangladesh. At lunch and dinner there is also a little curry; the cooks ladle out to each worker a few chunks of potato, one piece of meat and a

spoonful of the sauce. I am told this is often better and more than what they are able to eat at home. One worker tells me that the secret is to eat a lot of rice; that way one lies to one's stomach about not having eaten enough, and thereby make the pain of hunger go away for a while. Later that afternoon when I see him cheering furiously as he runs for the next piece of plate to load, I think that he lives certainly not on money, and maybe not on food either, but on spirit alone.

≈ ≈ ≈

The workers say little in my interviews with them. Their lives are determined by very simple and overwhelming conditions which they know they probably cannot change, only endure in the hope that life will somehow be better for the next generation. They have taken this job because it is relatively well paid and allows their families to subsist. Most of them dislike the work, and would leave in an instant if they could find a better, safer job, but for now they remain stuck here. They know the drill all too well to see any nuance in it. Today must be survived like yesterday; tomorrow barely appears to exist.

The hard, physical nature of the work is imprisoning. Even though workers have the freedom to take days off at will, there is never enough time to rest fully. The work stays in their bones. It never leaves them.

"Shesh," a worker tells me tiredly one afternoon towards the end of the breaking, which means "finished."

"*Kash?* (The work?)" I ask in response.

"*Na.* (No.)"

"*Jahaz?* (The ship?)"

"*Na, ami! Ami shesh.* (No, me! I am finished.)"

Of the two hundred or so workers in the yard, about ten are children under the legal working age of fourteen. Most tell me they are orphaned, or at least without a father to provide for them. Their extended families cannot support them either. The labor contractor does everything to keep them out of harm's way, giving them only light carrying tasks. At first it seems exploitative to see them here instead of going to school. Yet the contractor is doing them a favor, as the children's only alternative to the yards may be begging, if not starvation. It takes me a while to understand that these children have little choice in their lives. As much as the work is stunting their future, it is at least giving them a slightly more viable present in which to survive, one they may have lacked before coming to the yards.

Many more of the workers, especially the loaders, are still in their teens. Mushad is fifteen and comes from neighboring Kadam Rasul. He has been working for two years as a cutter's assistant. After the third grade he stopped going to school, and began looking for work to help alleviate his family's money problems. His father is a security guard in one of the neighboring yards, but does not earn enough to support his family of five children, of whom Mushad is the oldest. He only works four to five days a week, depending on when his cutter needs him. He would like to become a cutter himself, which would mean a higher and more stable income. The contractor considers him to be too young, and worries for his safety; in another two years they will reconsider. The family remains in financial crisis. I ask if Mushad's oldest younger brother, now twelve, will also work in the yards. The father doesn't think so, but I can't imagine he won't join them in another year, especially if more children arrive.

At fifteen he already carries the serious demeanor and worried countenance of an adult; the pressure to survive weighs on him. I also see the

On January 14, 1998,
at 2:20 p.m.,
the steamship *Minole* beached
in the breaking yards of
Fahad Steel Industries,
just north of Chittagong.

extent to which he is still a kid who likes to ride his bicycle and play cricket, who tells me he still wishes he could go to school. "When I grow up I want to buy a motorcycle, and ride it to visit you in America."

≈ ≈ ≈

The work is dangerous, sometimes fatal. The main cause of death is from tank explosions. Ships often arrive in Chittagong with residual petroleum product, crude or refined, in their holds. Shipowners often lie about the state of the ship. The port is unable to clean these vessels anyway, so in the end, officials simply turn a blind eye and authorize ships to be put ashore in this "dirty" state, transferring responsibility to the breaking yard. If the breaker and foremen are not experienced and careful, cutters may go into a tank with gas fumes or even sludge, light their torches, and burn to death in the ensuing explosion. In Alang, India, the world's other large shipbreaking area, one such blast is believed to have killed as many as forty workers. Two breaking yards to the north of Fahad Steel, a tank explosion claimed four lives in my last week there.

As maritime disasters such as tanker spills have often shown, accountability and liability in shipping are difficult to trace and establish even in the developed world. Once the ship has been beached, the shipowners are generally long gone and nowhere to be found. Even if they were, how would one hold them liable? The ship was inspected and cleared, they would claim. The inspectors would blame the port, who would in turn blame the present government. Everyone sooner or later blames the breakers, who are left to compensate the workers' families for anyone who dies or is hurt. The extent to which they do so is entirely at their discretion. The lack of international cooperation and regulation conjoin with Bangladesh's lack of a developed safety infrastructure to fail these workers miserably.

Injuries, some of them serious, are common. No one died during the cutting of the *Minole*, but a few had limbs smashed and bones broken. One loader lost the tip of his right index finger when the steel plank his group was about to hoist slipped, and pinched his hand. The tip of the bone protruded from the knuckle through the stub of flesh like a Popsicle stick. Even the ones who are not hurt, though, bear the imprint of the work. Loaders often develop huge calluses and scars on their shoulders from carrying the steel. One can only imagine the long-term effects of the heavy lifting on their spine, joints and muscles.

Given the crude, open nature of the demolition, and the worker's lack of protective gear, they are directly exposed to any number of toxic chemicals and materials: asbestos, PCBs, dioxins. Earlier this year, Greenpeace and the World Health Organization published a study of soil samples taken in shipbreaking yards in Mumbai and Alang, India, which states that, because of the contamination they are exposed to, cancer rates for long-term workers in the industry are disastrously higher than the average.

One might be inclined at first to blame the shipbreaker for the dangerous and dirty state of affairs which result from this lack of order, but the problem is larger than them, one that reaches back all the way to the shipyards who put such hazardous materials in the ships when they built them. I also do not find the breakers I meet, either as people or businessmen, to be without compassion and concern for their workers. I am unable to gauge how much more they can reasonably be expected to do, and, as I am under their protection, I am perhaps also hesitant to do so. The government is conspicuously absent from this discussion, however. It makes good money from shipbreaking through various forms of taxation; as the main buyer of the

rebar which is rerolled from the ships, it is also the prime beneficiary of the industry's advantages. Yet it does nothing to improve its conditions, be it in terms of funding and helping institute safety measures to protect the workers and the environment, or of making infrastructural improvements to the area, which would facilitate operations. The government prefers to ignore this convenient relationship, and as a result leaves shipbreaking largely unregulated; so far, it has not even placed the industry under any particular ministry. It too abandons the workers in this open, unprotected space, where they are left to pray for luck.

≈ ≈ ≈

Their working and living conditions appear miserable to me; however, I am not sure how harsh they seem to them. So much of the country is steeped in severe poverty that the breaking yards offer similar living conditions to other places, if not better. Everywhere one looks people are working and wearing themselves out. One day, while taking a rickshaw, I remark to Hossain that our driver is much stronger than any other we have had. He laughs and says, "That is because he is young; two more years will break him, and he will be weak like the others." Right then a bus passes us, spewing thick black fumes which make us all cough.

There is high turnover from season to season. Some move on to other jobs in the city of Chittagong, but most simply go to another yard for better pay or work arrangements. There does not seem to be any upward mobility. Many of the workers choose to return home after a few seasons; being together with their family and kin appears to be the most important thing. For many the additional money they earn is probably not worth the additional misery of the work and the separation from their traditional world, difficult as that existence has become.

Their migration embodies and symbolizes the growing pains that Bangladesh endures as it struggles to join the modern world and the global economy, caught between a past that seems less and less viable, and a future that remains out of reach. Modernity's promises are thorny to these people who risk not only their lives, but also the rupture of their cultural continuity. Their situation is desperate, and one fears they have few, if any, other choices.

Some of the workers manage to prosper through the industry. Chofi, the "wire" foreman, is from Baro Aulia, a village at the northern edge of the shipbreaking beaches, where he lives with his wife and two small children, as well as his mother and siblings. At thirty-one he is the oldest son of his father's second family. His father worked as a stonemason, but could not support all his children. As a result of the financial hardships his family endured during his childhood, Chofi did not go to school for very long, and at the age of fourteen began working in the shipbreaking yards, first as a fitter, then as a cutter, and finally as a wire foreman. He now provides for his whole extended family.

For his abilities and his character he is one of the most respected people in the yard; at 10,000 Tk a month, he is also one of the best paid. He gets two days paid vacation a month, and receives bonuses for the two Eid holidays. Along with everyone else, he works six and a half days a week, and although his hours are generally twelve a day, they can go as high as twenty. He is energetic and, unlike many, appears to thrive on the work.

What is most interesting about him is that he uses his salary to buy land, which his younger brothers manage for him. He tells me he owns more than three hundred hectares north of the yards in the village of Baro Aulia, most of it under cultivation. Much of the country is leaving the land for the city, yet he is headed in the opposite direction, using his resources to go back to the land. He is in some ways a very simple person. He remains barely literate, and holds no ambitions of opening a business, as many of the other workers claim to. He thinks he will work his whole life in the yards. He would like his children to go all the way through twelfth grade, but has otherwise not given much thought to their future after school.

Last year he traveled to West Bengal to visit Calcutta and several religious shrines, including Ajmer in Rajasthan. He plans to go back next year to see Mumbai and Delhi. He is an extraordinary combination of static contentment and curious restlessness.

≈ ≈ ≈

The workers' response to me is extraordinarily welcoming. At first, curious as they clearly seemed, they remained cautious; however, once they saw that I was quick to share a laugh with them, they dropped all barriers, and became very effusive. I get the impression that I am the first white person with whom many of them have ever seen, let alone spoken to. They are warm, friendly, and vivacious to the point of bullishness. They celebrate me with more attention than I care to attract; in the middle of the most difficult tasks, much to the chagrin of the foremen, they let themselves be distracted by my presence to talk with me, or share a joke.

The workers are especially curious about my photographing them, and eager to participate in the process. In my ignorance of Bengali and Muslim customs, I had feared that people would not want to be photographed for religious or cultural reasons, and that I would have to spend a lot of my time winning people's trust. It turned out that it is more difficult for me to learn to trust them. To my happy surprise, Bengalis are very open, spontaneous, and very performative. My greatest challenge is keeping people out of the frame. Whenever I point my camera in any direction, or at anyone, people often make a mad dash to be in the picture. Very often, entire loading crews stop while carrying heavy plate, and insist vehemently that I photograph them while they cheer and smile widely. In these moments the contrast between the harshness of their work and the lightness of their spirit verges on the surreal.

People often stare into my lens, hoping, I think, to see as much of me as I do of them looking

The deck shakes; the steel groans as it twists free, falling slowly and heavily through the air. It lands with a resounding, deep thud! which makes the ground bounce underfoot like a trampoline; the sound of the impact echoes off the neighboring hulls like a cannon shot. Mud sprays for many yards and a rising cloud of dust envelops the area. It settles with a brief pitter-patter of falling steel chips and slag that sounds like a momentary rainstorm.

outward. They often crowd around as I change my roll of film. I eventually interpret their disappointment upon viewing the small metal canister as having hoped to see the pictures themselves tumble out instead. They also love any pictures of them that I bring. They don't thank me, but instead complain that I have given them only one copy, and ask for more. At first I find this irritating, but eventually I learn to recognize this as a sign of their appreciation of the picture.

The breaking yards, which are my principal focus photographically, also become my main point of personal contact. The yard is a village of sorts where I know most people, and where I have come to have a place, foreign as I am to this world; we have learned to trust each other. After a day's absence, they are quick to ask why, and to express their concern that something was maybe wrong, or that I was abruptly leaving. As my Bengali improves somewhat, we begin to have simple conversations about our families, our homes, our future plans. Even as we repeat them tirelessly, confirming details about ourselves, we form a satisfying ritual of understanding. With some, I form enduring friendships. Their cheer and welcoming warmth coax me out of my hesitation and occasional confusion about where I stand.

≈ ≈ ≈

Whenever workers invite me to their home, they try to dispatch someone to buy a soda for me. They view soft drinks as a luxury in their world, and a sign of utmost hospitality; it is of the developed world, and therefore has an aura of sophistication and worldliness to it, one which they wish for me to experience, and to partake in themselves as well. They are very expensive for them. Small glass bottles cost a couple of hours of their labor. A two-liter bottle is half a day's wages.

The minute I see them pull money from their waist pocket, and wrangle with one of the countless kids who have come to stare at me from the doorway, I am quick to dissuade them from buying any. For me all of their strain and toil convert poorly into a small bottle of useless sugar water.

It is an offense to refuse, and so I consent instead to a much cheaper, and tastier cup of *cha* at the local "hotel", or cafe, outside the yard gates. At first they are flustered that I would prefer their drink of choice; don't I think it inferior, they seem to suggest? Slowly, though, they begin to see that I like and take interest in many aspects of their culture, that I consider it valuable and not at all inferior. In various ways they are made aware that the Western world generally proceeds with little interest in what happens in their lives, not the least of which is the rarity of someone like myself sitting with them, and savoring a cup of rich, delicious tea.

≈ ≈ ≈

Outside the yards I make limited movements. The bad impression which the shipping officials from the unloading made on me persists, and has left me paranoid that I could be taken advantage of at any moment. Instead of a visa, Hanif the agent ended up getting me only a shore pass, which on the back contains the stipulation under clause 4: "The seaman shall rejoin his ship before it sails." From time to time, I see some of these officials at a distance in the downtown area; I remain worried that they know of my arbitrary immigration status, and will try to extort money from me.

One day in the head office, Milon introduces me to a Greek shipowner who is in town to oversee the delivery of one of his ships to the breaking yards. Milon tells me that he just found out that the week before he had unwittingly avoided a carjacking,

which he fears was also meant to be a ransom kidnapping. He asks me what safety precautions I am taking. There are various hazards in the yards, but life outside them feels very risky and chaotic, on the verge of going out of control. I constantly see and hear about terrible things befalling people, and worry that I am as vulnerable and unprotected as they are. Moreover, as a foreigner I fear I am an especially conspicuous target. The raw, unmediated reality of life here suggests rather bluntly that one could easily die in any number of ways – in a traffic accident, from a strange illness, or in a mugging. Almost paternally Milon urges me to be careful wherever I go. The shipowner turns to me, smiling, and adds, "You never know what will happen in life."

Two hours later, when they go out to inspect his ship at anchorage, he dies when the pilot ladder he is climbing breaks and he falls thirty feet between the ship and the pilot vessel, his head smashing against the gunwale of the boat before his body slips into the murky water and is swept away by the churning current.

His words follow me everywhere.

≈ ≈ ≈

Many aspects of the local culture remain overwhelming. As bad as the yards seem, in some ways the destitution I witness in the streets of the city feels worse. The congestion of people and traffic is stifling, and its hectic pace too strenuous. I am eager to explore, but also remain afraid of this place I understand so little.

Crowds quickly form around me as I try to amble through various neighborhoods looking for things to photograph. My slow pace always attracts their attention. People are friendly, but communication is limited, and when an English speaker steps forward, the conversations often reiterate the same list of questions:

"Excuse me, my friend, are you Muslim?" I have grown a beard, in part as a secular emulation of this Muslim gesture of devotion; it is an expression of my dedication to photographing the ship.

"Are you married?"

"Why not?"

"What are you doing here?"

"Where is your home?"

"Will you take me to America?"

I try to explain that I can't, but they don't relent. They repeat and elaborate on the last question. Lengthy descriptions of immigration

policies are to no avail. My frustration at being unable to answer or help them, at not being listened to turns into impatience, aggravation and dismissiveness. As they continue their lobbying, they push in, and I begin to push out. The crowd parts, and I stomp off, feeling ungenerous for being so short tempered; they act embarrassed for having offended me, as well as disconcerted for not having meant to. Children, the least daunted by my grumpiness, follow me yelling random phrases of English, probably from the pages of their schoolbooks. "Hercules!" "The cow is a domestic animal, no?" "I like management structure!" Only after some time am I able to humor people and myself better by telling them that I can't take them, because they are so big and my bag is so small. This always elicits a laugh and puts an end to the questioning.

Taller and visibly paler than anyone else, most often with a camera on my person, I cannot claim even the slightest invisibility. I am halfway between a rock star and a circus elephant wherever I go, quickly the center of attention when I would instead prefer to be the discreet observer. I want to watch them, but they want to watch me more. Only when I learn to let them focus on me do they let their guard down, and let me photograph them with some measure of ease.

I eventually recognize that I am as foreign and unusual to them as they are to me. Although frequently sighted in Dhaka, Westerners are rarely seen in this more provincial city. I calculated that there were as few as twenty or thirty (of whom I met only two towards the end of my stay) living in this city of several millions, and hardly any who are just visiting. Not only have many of the people who accost me never seen or spoken with a Westerner, they have little idea of me from representations in the media, given their high rate of illiteracy and poor access to television, which here hardly shows white people anyway. Satellite television with its slew of international channels is available in just a few of Dhaka's fancier hotels. The West is barely visible here. One day a man waves to me from across the street, then darts across the thick traffic to ask me urgently, "Please tell me, Sir. Are you Korean or Japanese? I must know. Thank you very much."

≈ ≈ ≈

I often retreat to the comfort and insularity of my private surroundings, which is a mixed blessing. I have little extended contact with people outside the yards. Much of it is with my assistant, Hossain. His English is better than most, but our communication is limited, and still subject to all sorts of misunderstandings. "Yes, yes!" is the phrase I eventually come to identify as the source of wrong turns. It means, "I heard what you said, but did not understand; out of deference I am acknowledging that you said something, but out of embarrassment will not tell you that I might need further explanation."

He is good company nevertheless. Having worked as a seaman for several years, and seen much of the globe, he is full of lively stories. In my favorite one, he and a shipmate get robbed on the Sugar Mountain in Rio de Janeiro. The muggers herd them into the bushes of the crowded tourist area at knifepoint, and take their belongings. They also take almost all their clothes to prevent the two from following them out of the thicket to denounce them to the crowd. Hossain, in his underwear, and the other sailor, in his undershirt, now fashioned into an improvised pair of shorts, must walk all the way back down through the city and to the port, where they receive an exuberant, jeering welcome back from the rest of the crew, who needed no explanation to understand what had happened.

I am completely dependent on Hossain for all of my logistical concerns, which keeps him busy

most days of the week, and am therefore cautious about doing so for my social needs as well. In his own life he has mounting family problems; as time goes on, he is less able to give of himself, and perfunctorily confines himself to his basic duties.

I live in a *shilakota*, a rooftop apartment rented to me by Zakir, one of the ship's brokers. He owns the building, and lives on the bottom floors. The top three floors are unfinished. My room is monastic, but serene. It is furnished with a bed, a coffee table, and some couches. The windows on all four sides make it very luminous throughout the day. It has a simple bathroom consisting of a toilet and a cold-water hose. There is a gas hook-up on one of the empty floors below where Hossain cooks for me. Two patios on the roof overlook the bustling neighborhood and surrounding green hills. It feels like a bird's perch, safe and removed.

In this space, my mind retains a certain cultural sovereignty, lonely and blank as that often feels. I pour myself into my journal and writing letters. There is no phone. I call my mother once every ten days from a public phone store, which is an ordeal, as it takes many tries to get a line, if it works at all. The Internet is not publicly available, and cell phones are an expensive rarity as well. I live for the faxes and letters sent to the office, which one of the office messengers brings to me on his way home. Every night I listen for the sound of his footsteps climbing the stairs.

In the beginning I do not have enough reading material. There are no English language bookstores, and few magazines that I can read at the newsstand. Those I do occasionally find, an issue of The Economist or Newsweek Asia, go down like an intellectual rice cake – quickly consumed, and leaving little satisfaction once digested. A few people send me packages of books, half of which eventually make it to me. Even then it remains a challenge to keep an ample amount of information at hand; it feels like trying to stockpile a sufficient quantity of drinking water.

Most days of the week I go to the yards, but there are many times when I feel so overloaded that I spend the whole day inside, barricaded in my room. I decompress by not dealing with my surroundings, but pressurize for not having any distractions. Outside is a world teeming with life and dense social contact; their voices, always with each other, to be heard at all hours of the day and night, remind me of my own isolation. The society around me churns on with great vigor and happiness, and leaves me feeling weak and alone in comparison.

I notice this especially when the power goes out, which it does as many as four times a night. In chorus the voices sigh and become quieter as it goes dark; when the lights come back on, the voices cheer in celebration and resume their usual volume. This ritual repeats itself with the same enthusiasm no matter how many times a night we lose power.

≈ ≈ ≈

Shahin originally told me that he expected to finish the ship in two and a half months. A month goes by, and the breaking is still two and a half months away from completion. Another month later, always with the same tone of certainty, Shahin tells me yet again that the ship is two and a half months away from being finished. With considerable enthusiasm he also says he may buy another ship, and start demolishing it instead.

I wonder whether I can last. I know that I am free to leave at any time, but this is no consolation, determined as I am to finish photographing the breaking of my ship. I feel utterly alone. The total freedom of living so relatively anonymously within a foreign culture, where I do not have to adhere to many of my usual norms, feels amorphous; there are few boundaries now, and I feel myself at risk of slipping into a sort of emotional lawlessness. Somehow days, even weeks, pass in this state.

I see Captain Anam one day in the breaker's office after several weeks, and he reprimands me with his cheery, booming voice for not having come to see him and his family, who live very close to me. He is the person here who is most familiar with Western culture, having studied for a time in Britain, and sailed for many years for British companies. He has even visited various Atlantic ports in the U.S. and loves country music. As a result, it is easier for him to reach out to me than the other people I know, all of whom, it turns out, feel as challenged as I do in bridging the linguistic and cultural distance between us. He is the only one who sees my reserve as shyness and tries to compensate for it. I begin going to visit them and attending their various family functions. Oftentimes I spend the whole evening with his family at their home, sitting around the table and talking with him and his wife, Hasina, while their three children do their schoolwork. Occasionally they shyly peer at me, and exchange a muted giggle amongst themselves. Their company nourishes me, and they quickly become my family away from home. The breaker doesn't buy the additional ship, and instead speeds up the cutting. Life begins to feel normal again, and I emerge to meet it.

≈ ≈ ≈

Bangladesh thrives on recycling. The country has little economic power to import and consume many new products. It is striking how little is wasted. As much as plastic and polyethylene have invaded their lives, the country does not generate much garbage. Out and about it seems more than there actually is, because trash collection is not very organized; however within the context of people's homes, it is very obvious how little people waste. I notice that most objects I discard are quickly claimed for a new purpose, either private or commercial. Water bottles are reused indefinitely as containers for any liquid imaginable from honey to motor oil. Hossain gives my plastic film containers to a friend, who uses them for pharmaceutical storage. My few magazines, if not resold as is, become paper bags. Children reuse little drink boxes with straws as squirt guns. Itinerant cows and goats chew on mango and banana peels.

Out of necessity ships are self-sufficient, stocked with every imaginable provision, tool and

There will be no cranes or derricks, only the backs and arms of several hundred workers who will take her apart piece by piece, day after day.

material; they are a self-contained, complete world of goods, and they provide a resource to this society in a number of ways.

Some of the steel is used to build new ships. In Dhaka the southern shore of the Buriganga river is lined with yards that build vessels entirely from recycled steel. Most of the steel from the ship's hull, however, is rerolled into rebar and other steel shapes which are used in domestic construction. It is three times cheaper for Bangladesh to reroll ship steel than to buy it from abroad, or mill it from fresh, imported ore. This is a country without any mineral resources of its own; as a delta floodplain, its ground is all alluvial soil, without a gram of ore in it. There is not much of a modern infrastructure; for example many people, even in cities, still live in tin-roofed, thatched-wall huts, and use open sewers that run along the sides of streets. The rebar is needed to build not only homes, but all sorts of public and commercial buildings, as well as roads and bridges.

The brass and other nonferrous metals retrieved from propellers, valves, portholes and other parts makes their way to artisans in the Dhaka area, and through the Sundarban mangrove forest on smugglers' boats to India, where they are recast into ceremonial and decorative objects sold all over the world. Any brass object, from a fetish to a candleholder, that one finds in the West with a "Made in India" tag is cast from such brass.

Many items are removed from the ship intact for resale. Some, such as air conditioning compressors or workshop machinery, are reintegrated into small coastal vessels, or sold abroad; much of it, however, stays ashore. Generators power local factories during the frequent nightly blackouts. Lifeboats become local fishing craft, and doorways and partitioning drywall are reinstalled in homes, as are sinks, beds and furniture. Canned goods are resold in the markets along with plates and glasses that find their way into peoples' kitchens. Ship's flags are re-stitched to become door curtains. Life raft containers are reused as wheelbarrows.

Other items are dismantled, as their functional value exceeds their basic mineral worth. They were of no use anymore to the shipowner, but are worthless to the Bangladeshis as well. For example, an electric circuit board is worth far more for its content of copper wire, than it is as a whole, functioning piece that could be somehow reintegrated. Sometimes a radar unit will be stripped just for the silver in the contacts. Expensive batteries are mined for the nickel they contain.

Perhaps the only objects that were not readily reused were the Western toilets, as anybody who wanted one could afford them new. In the many stores along the Dhaka-Chittagong road selling ship goods, there were several places where these toilets were to be found idle in long, neat rows. One salesman had filled them with dirt and placed plants inside, hoping perhaps to sell them as garden curios.

≈ ≈ ≈

The steel is everywhere in people's lives. It forms not only the skeletons of buildings and other structures, be they bridges, lampposts, billboards, but almost anything imaginable. Angle iron is used to transform two-wheeled bicycles into three-wheeled rickshaws. The metal rod is used to make furniture, car fenders, bolts, railings, nails, handles, window bars, and chicken cages. Some of the steel is pounded flat to fashion knives, scissors, machetes, shovels; in a village I find a small garden hoe called a pashun, whose blade is made of steel and whose handle is a cow horn. One day I find a craftsman who makes small boat anchors from the rebar. Reluctantly amphibious, the ship returns to the water however it can.

One day I find a craftsman who makes small boat anchors from the rebar. Reluctantly amphibious, the ship returns to the water however it can.

The steel plate is transported to one of the many rerolling mills between Chittagong and Dhaka, where it will be made into rebar. Once unloaded from the truck, the steel is cut down to smaller strips, roughly six inches wide and three feet long, and placed in the forge for the evening's work. The mills only operate at night, because they generate so much heat; in the thick climate of daylight, the working conditions would be intolerable.

Workers pull the red-hot strips from the forge with long tongs and feed them into the mill, a line of revolving disks that shape and progressively compress the rebar. Once the fresh strip is placed into the mill, it shoots out the other side. There, another miller feeds it back again through a slightly smaller mill. The steel passes back and forth this way about ten times, growing longer and thinner each time, until it is as much as thirty feet in length.

For being so fast, the work looks more dangerous than that of the yards, but it is as spectacular to watch. The forge rages furiously while enormous, roaring fans try to dissipate the intense heat. Steel jumps out quickly and somewhat erratically from each side of the mill, like a glowing red snake on the attack. Here and there a miller bends over to rewrap the rags which cover his legs while a piece of steel shoots out between them; he appears not to notice as it leaps forth and skids to an unpredictable stop.

Workers then place the rebar onto a cooling pile for the rest of the night. In the morning workers take it three strands at a time and bend them into pretzeled, ten-foot lengths. They line the length of the rod and wrap it around a frame of planted posts. First one side bends a third of the rod back on itself, and then quickly thereafter the other side comes running in a large, sweeping motion to complete the bow. The worker in the middle gracefully rastles and ties the two ends over

the center with a small piece of wire, like a rodeo cowboy running a pigging string around a calf's legs. Then workers grab these bundles and throw them into the trucks.

In the approaching dawn one can see here and there a worker sleeping on a pile of cooling rebar after completing his shift; does he dream of the soft grass in the fields of home?

≈ ≈ ≈

The acquisition of metal forms a part of how we have historically measured a society's technological evolution and thereby evaluated its overall progress as a civilization. The various "ages" that began with copper, silver, gold and bronze culminated in iron, the basis for steel. The ability to work especially these last two metals allowed cultures to flourish by giving them more durable implements and weapons.

Does the acquisition of this steel represent believable progress to Bangladesh? Of course the country needs modern infrastructure. Will the steel be used to create structures that alleviate the problems faced in poor, overcrowded areas? Will it make them safer from the onslaught of cyclones, floods and rising oceans at a time when global warming is a particular threat to low-lying countries like Bangladesh? Will it make their lives better, or will it simply make them consume and pollute at an accelerated pace? I want to believe that steel represents a benefit; however, as I watch a variety of structures go up in the city, I feel only uncertainty and a slight dread that people here are struggling for something they will not achieve.

As much as the Bangladeshis' absorption of the metal represents a desire for progress, the sight of the last chunks of my ship lying in the mud has also filled me with regret for my own society. They are the last remnants of what we used to make so

My ship is finished, and so is my work, but not theirs; another ship waits for them at anchorage. They remain trapped in the unforgiving cycle which governs their existence: working to eat, and then eating to work.

well and are often failing to replace. Our modern economy seems founded on making money, more than things of actual value. In this system individual efforts are often diminished; craft and labor are rendered disposable, even irrelevant. The ship was an emblem of our former, seemingly solid prosperity. We are forsaking this tangible reality for a far less believable and chimerical social system – one which promises much, while also threatening to take it away again.

I once asked Mr. Durgapada, the head accountant, why the yard generates so much paperwork. Various people copy each transaction by hand into successive ledgers; their figures are reviewed by various managers and then brought to him for a final review and for copying into a final, oversized ledger. The process seems so laborious. Wouldn't it be simpler and faster to computerize everything?

"What would all those people do for work then?" he asks me, as his eyes look up over the top of his glasses, the point of his pen immobile on the wide paper. "The computer will let people change things, and lie more. It is not good." His other hand pats the beautiful ledger confidently, even affectionately, as he tells me, "No, Mr. Claudio, only this is real."

≈ ≈ ≈

The heat has remained unrelentingly high throughout the cutting. Only as the breaking comes to an end does the monsoon begin to arrive, breaking the heavy, unbearable climate. It brings the relief of cool winds and spectacular rainstorms that replace the sun with another, less merciful threat, that of potential flooding.

I am eager to see the ship finished. The project has occupied seven months of my life, wonderfully adventurous but overwhelming, fortunate but lonely, productive but exhausting. I am anxious to go home, even if I am no longer sure what that means; I have been counting the weeks, days, and now even the hours. Nevertheless I am devastated to leave on that last day. So many people have given me something of themselves in my stay there. For all the vast cultural differences that made our dealings sometimes incomprehensible, so much was exchanged that made our interaction rich and unique. I do not know how and when I will make it back so far to see them. Relieved as I feel, a sense of guilt also accompanies me in my departure. My ship is finished, and so is my work, but not theirs; another ship waits for them at anchorage. They remain trapped in the unforgiving cycle which governs their existence: working to eat, and then eating to work. It is a dynamic that benefits me as much as it hurts them.

≈ ≈ ≈

In the late afternoon my flight passes high over the yards; looking down I can still discern, amidst the field of some forty dead vessels, the remnants of my ship's boiler. Even though we cannot see each other, I wave to my friends, and I think they are waving to me. They know this is my plane. My mind is flooded with the many events of the last months. I am transported back to the beaching, our first arrival, our voyage, our departure, my catching the ship; past all that to what had brought me here. It was ten years before, and I was in a canoe with my family in Maine. We paddled softly through the delicate haze of dawn, past the many herons feeding along the exposed mudbanks of the ebb tide, to a spot where we had rowed so many times before: an island where ospreys nested. My brother and I pulled in the oars, and as the canoe coasted to a standstill, there was only quiet. My mother opened a small tin, and poured ashes which were once my father into the opaque gray-green water of the bay.

They saturated in the water for a brief moment, and then vanished instantly and fully. It was as if a primal source from the deep had reclaimed them. His life was surrendered to a larger process. Our tears, of grief and then also of consolation, followed him into that ocean.

I came to see a ship die and be reborn as I had my father, to watch life reconstitute itself in and out of forms, from those familiar and loved to ones new and unknown, each wonderful and magnificent, but ultimately impermanent and transitory. This was not a glorification of death, but a celebration of the ship's vitality. Like all living things she decomposed, and her material elements formed the basis of new organisms. She contained life, but was not herself life. Life did not remain within her, but passed through her.

As we fly past the yards, I look up. Above me, emerging in the darkening sky, I see a blanket of stars.

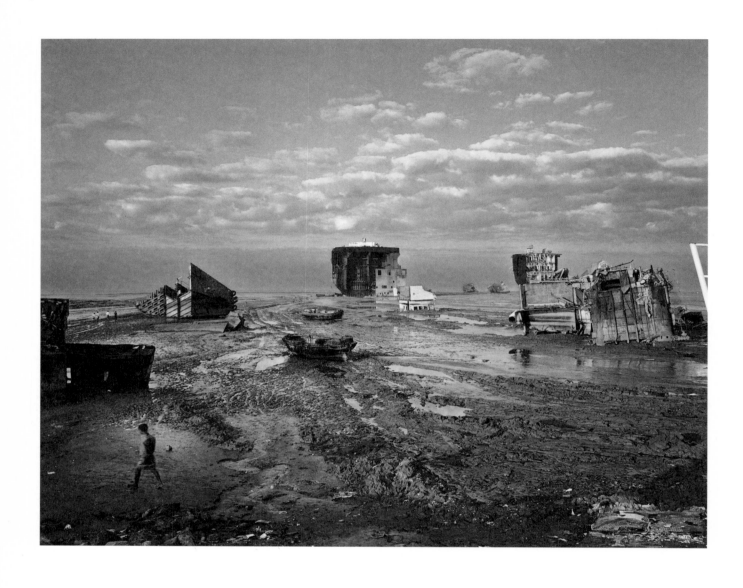

Sunrise, shipbreaking yard, Kadam Rasul, Bangladesh, December 2002

Return

Four years later I make the journey back to Shakdahoh with Ronju Ahmed to see his family. Mufad Jahal is in failing health and has been retired for two years. Ronju, himself now a loading foreman, is the family's sole source of income. When I first see how he has grown and even aged, I know that life has not been easy for him. He has come to hate working in the yards, but he has yet to find anything that pays better. Despite his strong work ethic, opportunities remain few. To make matters even worse, some yards have begun to automate the moving of cut steel. Cranes fitted with large magnets lift, sort and load steel in place of the loaders. In a few years his job may not exist anymore. I fear that the weight of his situation is marking him with a growing despair. He asks me repeatedly about getting a visa to the U.S., which he imagines can be bought, like those to the Middle East, where many Bangladeshis emigrate as guest workers through an often highly corrupt application process. Recently he fell for a scheme where he paid a shyster two weeks' salary to secure him a longshoreman's job on the docks. When Ronju asked for a guarantee, the man told him, "I cannot lie to you because, if I did, the ground would not accept my body when I die!" Needless to say, these lucrative jobs are all spoken for by various unions, and Ronju never heard from the man again.

It is a harrowing all-night bus ride to the Bogra district aboard an old coach that careens recklessly around oncoming traffic; the trip feels like a never-ending string of near accidents. I have reserved seats towards the back to avoid plunging through the windshield in the event of a head-on collision, and on the left side, away from potential scrapes against oncoming vehicles on the right; along with Ronju and everyone else I am terrified nonetheless. South of Dhaka we pass a gruesome wreck, and everyone mumbles that it could have been us. Just before the Jamuna River the approach becomes modern. From a bumpy road we come onto wide, perfectly paved and signed traffic lanes which bring us to the lengthy Bangabandhu bridge. It links the southern, more urbanized part of the country with the rural north. The bridge is a vital link between these two halves, and its modernity is a source of pride and optimism. For Bangladeshis it is as if the Golden Gate Bridge crossed over the Mississippi. It is several miles long, and once on the other side, people start talking excitedly. The border has been crossed, and home is close.

At dawn we jump off the moving bus in Sherpur, and cross the street to catch a smaller one that is slowly filling up. There is heavy fog, and it is quite cold, which seems so unusual for a country whose

climate is usually tropical and very hot. Everyone is bundled up in scarves, sweaters and earmuffs, rubbing their hands to keep warm. The rhythm of the dialect is noticeably slower and calmer here; people also appear more serene and relaxed. The driver waits for all the expected regulars to show up before we rumble through the flat countryside down a small, winding road lined with trees. People emerge out of the fog walking, riding bicycles, leading livestock, easily making way for us. Here even traffic seems serene, quaint, and hardly terrifying. The countryside serves as a more steadying backdrop than the chaos of urban spaces, which seem to confirm the fear that life there lunges forward into modernity without much direction or security.

Here, finally, I find the idyllic setting of Tagore's writings and Ray's films: wide expanses of meticulously cultivated fields of vegetables and yellow mustard flowers extending to the horizon, all faintly illuminated by the perfectly delineated orange disk of the sun glowing weakly as it rises through the fog. It is a revelation; I never expected to see this beautiful open space, having spent all my time in the cities, which are often characterized by congestion, disorder, and even squalor. In this pastoral landscape as manicured as a garden, one can instantly see the true richness of Bangladesh.

We get off the bus, and scramble down the roadbank onto a two-foot-wide raised footpath that leads off to the south through the fields. The world is still waking up as we walk through it. People pass us, briskly carrying their burdens of tools or baskets of vegetables to sell in the market. Some are already at work in the fields. At the edge of a village, an old man calmly surveys the scene. As I pass I offer my greeting in the standard, half-eaten pronunciation of Chittagong: "'S'lam'lekum" "Wa-haaaaai-li-kum assssss-a-laaaaam!" he answers slowly and piously, putting my hasty city ways to shame.

Ronju walks quickly, smiling from ear to ear. He is very excited to see his family after many months. To bring me along is an added treat. A guest, especially a foreigner, is a mark of honor. I have never seen him so animated. I have only watched him working in the yards, or relaxing in his quarters; in either place he is subdued from exhaustion and frustration. He works hard, but doesn't get ahead; whatever he saves he sends back here to his family. His financial situation is so tough, he tells me, that he doesn't imagine being able to get married for a long while. His present is bleak, and his future perhaps more so. Nevertheless, he diligently maintains his past, which nourishes him. He is coming back to the one thing in his world that makes him truly happy. Here I can see him coming back to life.

We enter the village to little fanfare. Ronju's mother glances up from the ground stove as we walk into the family's yard. A few silent, undemonstrative words are exchanged between them as Ronju keeps walking straight by, right into the house. It is as if he had never been away. Our visit was announced through the village cell phone in neighboring Pencheverri. A few days before leaving, we called from Chittagong on my cell phone, and made an appointment for an hour or so later. A messenger in the meantime traveled the few kilometers across the Bogra River and through the fields to Shakdahoh, and found Mufad Jahal, who returned with him, and waited for our second call. Ronju's mother fries duck eggs for us for breakfast, and then leads me into the house, and urges me to take a nap. Curious as I am to see everything, I also relish the chance to sleep off some of the long journey; it was only two hundred miles, but it took twelve hours.

The walls and roof of the house are tin, which is not particularly comfortable in the summer heat; however, for being ready made and waterproof, it is probably more convenient than making and maintaining thatch. The floor is raised earth. Within the house are beds, a bureau, shelves holding cooking pots. On the mostly bare walls I am surprised to

see portraits of Mufad Jahal and Ronju, and one with me, which I had made during my first visit. Much as I had often thought about them, I was happy and flattered to know that they had made such a place for these pictures in their home.

I wake up a few hours later to a familiar, but almost forgotten gesture. Mufad Jahal is stroking my shoulder to wake me up. Four years earlier, as we would sit and talk in the yards, often unable to communicate much through words, he would look at me and smile, stroking my arm and shoulder in this way to express his paternal affection for me. Compared to the portrait on the wall behind him, I can see he has aged considerably. Two years ago a doctor told him he was too weak for the yards, and advised him to stop working. He is one of the kindest, gentlest, humblest, most decent people I have ever met. I remember that he used to watch me pet the stray dogs in the ship-breaking yards, an event which always drew jeers from any onlookers. Dogs are considered unclean, and are generally not very well tolerated. Several times he would pet a dog with me, as if to express that no amount of orthodoxy could keep him from viewing this lowly creature as nevertheless one of God's creations, in itself also capable of kindness.

He brings me outside to meet Topi, his daughter whom he has brought along with her husband and mother-in-law from Pabna, an hour or two away. One of Ronju's maternal uncles has come as well. Eid is a time for families to visit one another, but it becomes clear from the huge roster of guests and the constant stream of people from within the village who come and stand around the fire, that it is also my visit which has occasioned theirs. Much of the conversation, from what I can pick up, centers around the basic facts of my person and visit: what I look like, whether I seem healthy or not, what I just ate that morning, how long I am staying, and why only so briefly. It feels as if I am performing, simply by being there as an object of curiosity, and that they are for me as well. This is not insincerity, but instead a sign of the extraordinariness of this visit for both sides. It is as if this small yard is the set of a play for both them and me. I watch a parade of characters enter and exit, and they, the sizable audience, come to see a seated, mostly silent, but smiling one-man show. I feel very removed from my familiar surroundings, but happily so. I am in the middle of a beautiful nowhere.

The focus of attention is Ronju's mother: she is the gear that makes everything turn. She spends most of the day crouched over the clay pit stove, preparing and cooking food. She is tall and thin. When she walks around the compound, her erect, upper body doesn't move,

and so she appears to glide like a ghost. Squatting alongside her, Topi stokes the fire with homemade fuel sticks of reeds and dried manure. She struggles to keep her composure; a few months pregnant, she is often nauseated from morning sickness. Her husband watches melancholically, not so much bored as languid. The mother-in-law sits slowly chewing paan in prodigious quantities. She watches everything with curiosity, but doesn't really help, as is her prerogative as a guest. To complicate matters further, she is not fond of being photographed, and chides me for doing so; as she is always practically in the center of activity, this makes for several rebukes. Around the fire of his own house, as everyone watches his wife cook, Mufad Jahal never sits, but always offers a chair to visitors; sometimes he even tends the fire himself, which is rare to see. A cow and calf are tethered to a tree next to a small haystack. A sheep lies in the shade, and chickens wander freely everywhere. On the outer edges cats competitively search for scraps.

His mother works constantly, cooking and cleaning, as if she were racing to keep up. Even at night, as we all go to sleep, she chops betel nut for her in-laws. She carries the stress of the family in her face. She complains to me repeatedly that they are poor, that there are money problems. Her voice is pained, and whimpering. At first I am suspicious that this is a prelude to asking for a handout, but it is not. It's just the truth, and she is shouting it out to me. There is also a component of shame; they wish they could offer me something more than their humble surroundings. They often apologize.

She is sick. She has heavy migraines, and digestive problems as well. She and Topi are often forced to take turns tending to the day's chores while the other lies down. Their well water is not very good; even when boiled, it makes me sick. For them to go see a doctor and get the appropriate injection costs several days' wages. She will require an operation and despite his own failing health, Mufad Jahal will have to go back to work in the yards for a few months to pay for it. I discreetly make a contribution, but I don't know if it is enough, or even whether it will be used to meet other obligations instead.

Here, one witnesses the failures of the traditional way of life of subsistence. People, even the landless, can often maintain themselves to a sufficient measure until there is an extraordinary expenditure: a daughter's wedding, a mother's operation, a premature death of a parent. This is when old men must leave their retirement, and young children their school, and both are forced to migrate in search of work. Mufad Jahal is relatively lucky that he has a ready, slightly profitable source of income to return to. Many of the young men in the village talk of coming to Chittagong with us, but without the slightest prospect or understanding of where to go. Topon, one of Ronju's friends, insists on returning with us, and I buy him a ticket; this will be the first time he has left the village. A culture's stability is under threat; it can only survive by disbanding, and then trying to regroup. This is true both here and the world over, within countries and across borders, as people are increasingly on the move, all the while dreaming of staying put.

We spend a bit of time going from house to house meeting all of Ronju's relatives. One of his second cousins speaks good English. Shima is twenty-four, the middle daughter of Ronju's mother's cousin. She lives with and takes care of her grandmother, who is quite old and frail, and spends much of her time resting in bed. Shima is also studying for her entrance exams for Rajshahi University later that winter. She hasn't found he courage to tell her grandmother she may leave for fear of breaking her heart. I think she will be one of the first people to go to university from this village. She describes her parents as very supportive and permissive. She even told her father recently that she does not want an arranged marriage, and that she wants to choose

her own partner. In front of the house she shows me a tandoor-like structure which, when opened, reveals a flurry of chicken and chicks that come out for their feeding. She tells me that she will sell these to help pay for her expenses at college. Somewhat bitterly she also tells me that her aunts have not supported her in any way; it has all been on her shoulders.

She is a born leader, and I hope that she will succeed. She has everyone's respect for being intelligent and educated. Will she have enough money to go? Will they allow her to leave and grow to her full potential? Or will traditional collective dynamics demand ultimately that she stay within the context of the village and her kinship structure? Many of the men, especially the younger ones, leave for work, but it may be unprecedented that a woman leaves on her own for a reason other than marriage.

I want to go see where the Jamuna claimed their land. We cross fields, are ferried across a small river in a boat, and walk to the paved road. We take a rickshaw to the nearest town, then a bus, then another rickshaw along a raised dirt track for several kilometers. It feels very remote, more so than Shakdahoh. We walk out onto a jetty that was built to stem the erosion that had caused so much damage here. The river is wide and majestic. A few clouds dotting the wide sky are reflected quietly in the smooth water. Boats ply their way along the coast. Children play in a small side channel, and someone sings in a field. From afar the water carries the voices to us. The scene is breathtaking. Mufad Jahal points to the water a few hundred yards out from shore; to see it so beautiful, who would know the river had taken his prosperity? No one wants to stay. After only ten minutes, everyone is restless and ready to move on.

During the course of the visit, Ronju sees all of his relations, and talks to others on the neighboring village cell phone. He preserves and reaffirms his bonds with everyone before plunging himself back into the isolation of the shipbreaking yards. We spend some time exploring the surrounding area. I tell him repeatedly how beautiful I find it. He also views it with great pleasure; it is clearly important to him. The aesthetics of the landscape are not merely ornamental, but an integral part of these people's lives. The consoling beauty of the land is part of the coherence of their original world which they are struggling to preserve.

Our leaving is more ceremonious than our arrival. Many assemble to say goodbye. Topon, however, is nowhere to be found. Word eventually comes that he will leave a few weeks from now; he was too

embarrassed to see us off. In the end, he was probably too afraid to leave. When it is time to go, Ronju begins to greet his elders. He bends over to touch their feet, then his chest, as they offer their blessing by touching his forehead. As we leave a group of twenty or so accompany us to the edge of the village. They grow smaller, and the landscape grows bigger around them. For as long as we are in sight, they wave to us, and Ronju looks back at them. Every second that he can still see them counts. As we turn the final corner he mutters something which seems to say that the departure is now real, that the link has been broken again. The village is so enveloping, that to leave feels like tearing ourselves out of a social fabric that has absorbed us fully. It is clearer than ever to me how much he hates the work, not just in itself, but for the enforced separation from his original world. For him it is exile.

Mufad Jahal walks with us for another stretch, and it breaks my heart to take leave of him. In the seconds which pass as we walk away I watch him standing there like a receding icon in the path. I wonder if I will ever see him again. The friendship and care he expresses to me are very real. Amidst the vast cultural differences, the huge language gap, I ask myself whether I understand how real this friendship is, or whether I view it merely as a cultural curiosity of my touristic wanderings. Have I made a place for him as he has for me? Time is short and the distances are so great, but I am determined to come back.

We make the journey back into time, from myth back to modernity: to the tree-lined road, back to Sherpur, now noisy and dusty at midday, back across the Bangabandhu Bridge. Ronju watches the scenery attentively through the bus window as we cross the river, then turns to me and smiles as that world seems to wash away so quickly.

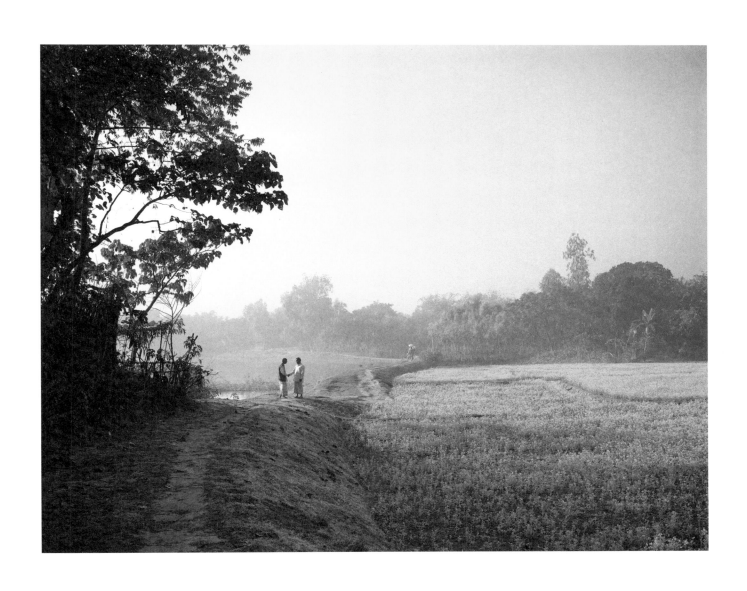

Shakdahoh, Bogra District, Bangladesh

Postscript

I wrote this book mostly in the present tense to preserve a sense of emotional immediacy to my experiences; however, this risks presenting as factually current various aspects of life in the ship-breaking yards and Bangladesh in general that I witnessed more than 15 years ago and which have changed since then, often considerably. Many things I describe should, therefore, be taken only as specific to what I saw at that time. For that matter, this narrative remains an eyewitness account, and as such, it does not engage in some of the polemics that tend to characterize much of the discussion of this industry, because such abstract analysis is largely beyond the scope of what the camera sees and what I was otherwise able to comprehend empirically.

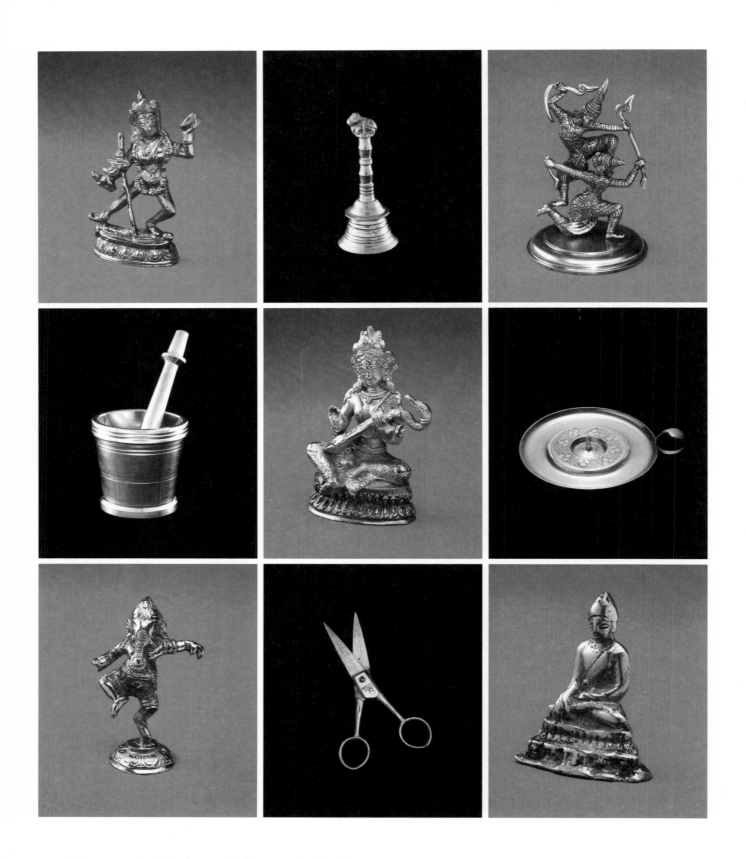

Objects sacred and profane made from recycled ship brass

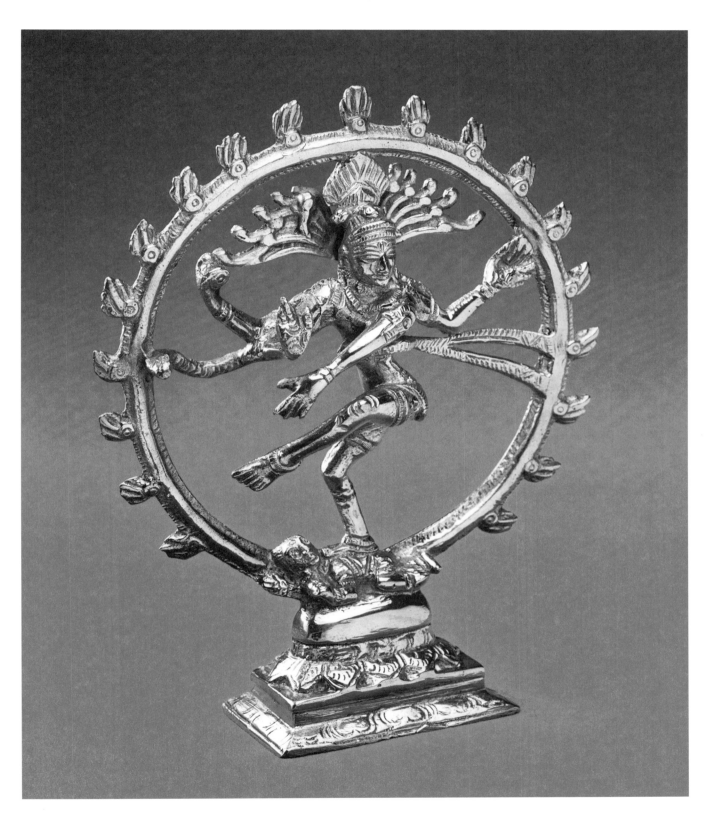

Shiva Nataraj, dancing to destroy and recreate the universe
(made from brass recycled from ships)

Acknowledgements

This book would not have been possible without the support of many.

My first thanks go to all the people who make their hard living from ships who let me photograph them, from the US all the way to Bangladesh and back. You bring the pictures to life.

As importantly, many people helped me get to the point of being able make these photographs. This project grew out of a desire to document the disappearance of the US Merchant Marine, and as such, it was born in the San Francisco union halls where I first began making portraits of sailors. My thanks to the late, great Andy Andersen, SUP dispatcher, who first told me about shipbreaking in long ago 1995. Steady as she goes, Andy. To all the seamen in the SUP, MMP, SIU, MEBA, and NMU hiring halls across the US whom I photographed and interviewed, thank you for the many lessons learned and for as many good stories, all of them true, no doubt. I wish to thank friends and colleagues in San Francisco and Los Angeles for their encouragement to pursue this idea, which initially seemed as far-fetched as it was compelling: Sherrod Blankner and Andy Clason, Alice Chen and David Bilder, Anne Fishbein, Gail and Boas Halaban, Karen Halverson, May Mantell, Max Pinigin, Jonathan Reff, and Deric and Barbara Washburn.

Many thanks to Cecil McIntyre of the MEBA and Paul Nielsen of the MMP, who provided my first contacts to the world of shipowners and government officials. Thanks also to Ned Mantell for his suggestions, and to George Clark at Keystone and Elliot Levin at Afram for entertaining proposals from me to ride on their companies' ships, even though this proved unfeasible. Across the pond, I owe a special debt of gratitude to Ian Bouskill at the IMIF in London, who kindly offered many concrete and fruitful leads early on in my search. Fran Olsen, formerly at MARAD, was my angel on several occasions, making the decisive connection for me to August Trading, and later on to the Atlantic Monthly, which first published some of this work in August 2000. Carl Mastandrea and Brittain Smith dropped everything to write letters of recommendation that helped me get on my ship.

My great gratitude goes to Rick Stickle, owner of August Trading, who gave me permission to travel as a passenger on his ship, the SS Minole. Without his trust and generosity, this project would not have come to fruition. Many thanks to all my shipmates for a trip few of us will ever forget, especially Captain Steve Clark, Ron Wood, Jim Joyce, Jack Johnson, David Penchina, Bob Organ, John Wallace, Harry Joe Fluker, Noah Tanihu, Steve Taylor and Richard Johnson, with a special thanks to the late Bill Sword. All of you helped me find my way to pictures I would otherwise have missed.

In Bangladesh, Milon, Shahin, and the late Zakir took me in immediately; they not only gave me access to their shipbreaking yard, but also provided me with a place to live and constantly watched over me. The person to whom I owe the most in Chittagong, though, then and since, is Capt. Anam Chowdhury, half a father, half a big brother, always a friend. To Anam, his wife Hasina, their children and extended family, who opened their hearts and home to me on this and many subsequent visits to Bangladesh, I owe my happiness, health, sanity, and probably my very life on several occasions. Oshonko dhonnobad. Hossain Deloar was the world's greatest assistant and manager, without whom I would not have been able to navigate such an initially unfamiliar place. I am also grateful to Sujan Sharif and his family for going out of their way to make me feel at home. Many thanks to everyone at the erstwhile OTBL, especially Mithu, Mazed, Durgapada, Mr. Das, Aminul, and Shah Jahan, and everyone at Fahad Steel, especially Mufad Jahal and Ronju Ahmed, for all your smiles, as well as to the many breakers who let me enter their yards and rerolling mills freely, especially Shah Jahan, Liaqat, Yassin, and the 2 Mohsins. To all my friends who wrote me while I was away and who buoyed my spirits, thank you. And for their warmth and their example, I owe a special debt to Peter and Caroline Bauer, both departed, and still missed.

Upon returning to Los Angeles 7 months later, I built a darkroom and workspace in my garage with the expert assistance and good cheer of Anatoly Petrenko, Jessica Simmons, Christof Bove, Anthony Manniello, and Leslie Tamaribuchi. My mother, Marlis Zeller Cambon, then and on so many other occasions before and since, provided moral and financial support, which allowed me to process hundreds of rolls of film and make prints. And when I was evicted at the tail end of that process, Nancy Giffin let me set it all back up in her garage. Jeff Li went to all lengths to let me use his studio and gear to photograph the brass objects. Thank you.

Vielen, vielen Dank to Capt. Klaus Lohse, who introduced me to many of the ship's former officers and crew, including Al Wheeler, Captain Rogers Schwartz, Paul Hughes, Johnny Petrovich, and Todd Watts, all of whom shared their experiences of sailing aboard the Mobil Meridian, then renamed the Seminole. Infinite thanks to Anthony Urbanelli, Russ Lindblad, Susan Coulson, Ronald Taylor, and others at Mobil Shipping Corporation who went to great lengths to allow me to travel on the American Progress for 2 weeks in November 1998, and who also located some of the ship's original blueprints for me. I remain grateful to Captain Tim Wood and the entire crew of the American Progress, who generously gave of themselves in recounting stories of their working lives aboard the Meridian/Seminole. Thanks to Baltimore Marine Industries for giving me five minutes to photograph the slipways on which Hull #4577 was launched; Tony Brocato, grazie della compagnia! I am grateful to Norman Smith and Bob Jarrett, retired Sparrow's Point employees, for sharing their shipbuilding expertise and historical insight. Bette Kovach, former director of public relations at Bethlehem Steel, enthusiastically took on the nigh-impossible task of locating the ship's launch photographs, which she miraculously accomplished.

My thanks to the many people who helped me first exhibit and publish this work, especially William Langewiesche and Robin Gilmore-Barnes at the Atlantic Monthly, Chris Rauschenberg, Tom Champion and everyone at Blue Sky Gallery, Guido Fink, Giovanni Zamboni Paulis and Alma Ruiz at the Istituto Italiano di Cultura di Los Angeles, Teresa Fiore in the L'Italo Americano, Juan Alberto Gaviria of the Centro Colombo Americano and Pilar Velilla and Alberto Sierra Maya at the Museo de Antioquia in Medellín, Skip and Lis Kohloff at the Colorado Photographic Arts Center, Scott Baker at Metroform Gallery in Tuscon, Shahidul Alam at Drik in Dhaka, Max Page at UMass/Amherst, Tom Jimison at MTSU, Anja Dijkhuizen, Irene Jacobs, and Rinske Juergens at the Maritiem Museum Rotterdam, the directors and staff of the Museo Italo-Americano in San Francisco and the Voyager National Maritime

Museum in Auckland, with a special thanks to Elaine Markson for trying so hard to get a book published in the US.

I am grateful for the support I received from family and friends who provided endless encouragement and support, often in the form of buying prints to help me continue the project, especially Erick and Natalie Gude, Steffen Cambon, Elsa Casillas, Mona Soo Hoo and her entire family, including Zeus for the many hours of good company, the O'Neills, Brendan Moriarty and family, David Conrad, Dan Schrag and Diane Brockmeyer, You Mon Tsang and Mary Flynn, Anthony Bregman and Malaika Amon, Michael Berman and Holly Sklar, Carolyn Koo, Christopher and Chloe Martin, Karen and Don Moser, James and Anita Timmons, Nancy Dorian, the Chovnick family, Nicole and Geoff Parsons, Beau Valtz and Galen Malicoat, Keith and Rosmarie Waldrop, Douglas Wong, and Tim Wride, among many others. This book also wishes to honor the memory of two family matriarchs, both departed: my cousin Letizia Cambon Asquini and my godmother, Antonia J. Warren, whose example and support helped nourish this project. A special debt of gratitude to Lee Fontanella for his mentorship and friendship across the decades, for support and criticism, whichever was appropriate, and for the many good laughs, which have always been necessary.

Many years went by before this project finally found its home at Edition Patrick Frey. Without Eric Rosencrantz, who procures all the good things in this world for me, I never would have made the initial connection. Merci. My infinite thanks to Andrea Kempter, who first solicited a proposal from me, lobbied for it with all her heart, and watched over it from start to finish; the book has clearly benefited from her wisdom and guidance. Of course my immense gratitude goes to Patrick Frey himself for believing in the worth of this project, for granting me so much creative freedom, and ultimately, for taking the joyous but not simple leap of faith in publishing this book. Hugh Milstein at Digital Fusion made all the scans from the original negatives and then painstakingly retouched the images, making them better, as he always does; this collaboration has become an essential part of the photographs. Joe, Lena, and Masha Wolek provided a home away from home in this process, as they have many times; spassiba for always having my back. Michael Isenberg patiently found the negative for the cover photograph, hidden in plain sight. Simon Pare, the world's greatest proofreader and editor, helped clean up many of the inconsistencies in the text; thanks, mate! Katarina Lang and Frank Hyde-Antwi, the book's designers, achieved that most delicate and rare balance of respecting my intentions and bringing so much of themselves to the project as well; the book has exceeded all my expectations because of the refinement, serenity, and clarity which they bring to their work. How soon these days of passage were over …

To all those who contributed in other ways to this project whom I have not mentioned here (including the author Joseph Campbell, whom – he would probably be pleased to know – I unwittingly channeled in the using the light bulb simile!), and to my friends in general scattered across the world, my gratitude remains; this book and my life are all the richer for your presence.

Most of all, my heart goes to my family, to Usha, Deeya, and Elisa, my angels, my laughter, my sunshine. Without you I would be lost.

Claudio Cambon, Shipbreak

Photo Credits: All photographs by Claudio Cambon, except for the launch photographs on pages 6–7, which are courtesy of Bethlehem Steel Corporation.

Text: Claudio Cambon
Editing and proofreading: "Sir" Simon Pare

Book design: Frank Hyde-Antwi + Katarina Lang Loveridge
Scans: Digital Fusion, Culver City, California
Printed and bound by Kösel, Germany
Paper for text: Munken Print Cream 1,8, 115 gm²
Paper for photos: Tatami White 135 gm²
Cover: Peyer Naturleinen
Fonts: Bembo, Bodebeck

Front and back endpapers: Details from the blueprints drafted by Bethlehem Steel Sparrow's Point Shipyard for hull #4577, christened the *Stanvac Meridian* in November 1961 and decommissioned in January 1998 as the *Minole*.

Edition Patrick Frey, Limmatstrasse 268, CH-8005 Zurich
www.editionpatrickfrey.com
mail@editionpatrickfrey.ch

First edition: Edition Patrick Frey, 2015
ISBN 978-3-905929-84-3
Printed in Germany

Distribution
Switzerland:
AVA Verlagsauslieferung, CH – Affoltern am Albis
ava.ch

Germany, Austria:
GVA Gemeinsame Verlagsauslieferung, D – Göttingen
gva-verlage.de

France, Luxembourg, Belgium:
Les presses du réel, F – Dijon
lespressesdureel.com

United Kingdom:
Antenne Books, GB – London
antennebooks.com

Japan:
Marginal Press, JP – Tokyo
marginal-press.com

USA:
RAM Publications and distributions, USA – Santa Monica
rampub.com

Australia, New Zealand:
Perimeter Distribution, AU – Melbourne
perimeterdistribution.com

Rest of the world:
Edition Patrick Frey, CH – Zurich
editionpatrickfrey.com

9-87

" x 20.4 #

PLT. SEE
AT UPPER,
ECK

20.4 BKT FOR BLT'S
NOT SHOWN SEE BKT
AT UPPER DK
9-70

5" FLG

6" Ex. Str. Stan. △'
For Dets. of Bkts. - See Elev.
At £ (H4577 ONLY)

6" x 1/2 FB
9-81

9-80

5/16 ▷

20.4 #

£ OF SHID

-1/2

18"

9-

5" FLG

20.4 #
9-78

20"

38